Catawba Nation

Tom Blumer

THOMAS J. BLUMER

Catawba Nation

TREASURES IN HISTORY

FOREWORD BY ROBERT P. SMITH
AFTERWORD BY E. FRED SANDERS

Charleston London

History
PRESS

Published by The History Press
Charleston, SC 29403
www.historypress.net

Cover image: The John and Rachel Brown family at the Columbia Corn Exposition in 1913. The children are unidentified.

First published 2007
Manufactured in the United Kingdom

ISBN 978.1.59629.163.8

Library of Congress Cataloging-in-Publication Data

Blumer, Thomas J., 1937-
 Catawba Nation : treasures in history / Thomas J. Blumer ; edited
with an introduction by Robert P. Smith.
 p. cm.
 Includes bibliographical references.
 ISBN-13: 978-1-59629-163-8 (alk. paper)
 1. Catawba Indians--History. 2. Catawba Indians--Wars. 3. Catawba
Indians--Government relations. 4. South Carolina--History. I. Smith,
Robert P. (Robert Patrick), 1965- II. Title.
 E99.C24B575 2006
 975.7004'9752--dc22
 2006027436

Dedicated to my four children:

Theresa Ann Marie Blumer Sahhar

Susannah June Marie Blumer Christenson

Mary Margaret Guadalupe Blumer Chargois

John Jakob Robert Lee Blumer

Contents

Contents

Acknowledgements

Catawba Nation: Treasures in History was begun when I was approximately halfway through the transfer of my papers from my home in Edinburg, Virginia, and then later to South Carolina and then from my home here in Lancaster to the University of South Carolina, Lancaster, Medford Library. The odyssey ended, they are now housed in a newly formed archive named the T.J. Blumer Catawba Research Collection. Naturally my reference files had to be reorganized, and this daunting task was brilliantly done by archivist Brent Burgin. As I faced my collection in new surroundings, Burgin was always ready to help me and he became my personal finding aid. Other library personnel who stood ready to help me included head librarian Shari Eliades, Lori Harris (head of public services) and Rose-Ellen (Dafney) Eckberg (government document librarian). I know so many Catawba who are always ready to give of themselves to me and my work of too many years that naming them all would be close to a tribal roll. Those Catawba that I have been in most contact with include Helen Canty Beck, Catawba traditionalist; Sammy Beck, Catawba secretary/treasurer; Anna Brown, Catawba linguist; Keith Brown, master potter and Catawba storyteller; Susan George, Catawba and would-be cousin; Deborah Harris Crisco, Catawba political activist; Jim Largo, Navajo powwow organizer; Della Harris Oxendine, Catawba potter; Cheryl and Brian Sanders, master Catawba potters; Donnie Sanders, Catawba potter; Fred Sanders, Catawba councilman; Bruce Wade, Catawba, who seems to be doubling as a Lakota chief of great notoriety; Gabriel White, Catawba, who has promised to make me some Catawba beads; and a host of others who always encourage me in my ongoing Catawba work with a bit of banter and a hearty smile. Here in Lancaster my major support came from Lindsay Pettus and Sandy Nelson of the Pettus Real Estate Office. The book would have been unthinkable without the help of my editor, Robert Patrick Smith, who is the director of the Catawba Big Head Turtle Productions Project. The project is endeavoring to record, in DVD format, contemporary Catawba pottery-making methods. Lastly, my children call me often and wish me good cheer from various places in Yankee Land, and my dog Sadie is always a foot behind me when I am at home and sits in the window looking for me when I am not.

Foreword

In order to better understand what you are about to read, you should first briefly get to know the man who wrote it. Thomas J. Blumer is a man who has dedicated a large part of his life to a passionate study of a wonderful people, the Catawba Native Americans.

Life began for Tom in Freeport, New York, at 7:00 a.m. on July 7, 1937. He was the seventh child that his parents, Gordon and Viola, looked forward to raising. He had one sister, June Ruth, and a brother, John, who subsequently died at birth. All of Viola's other attempts to have a child other then June Ruth ended in tragedy until their son Tom entered the picture.

Tom's early education consisted of the public schools of Freeport and catechism at Holy Redeemer Roman Catholic Church. His education continued while he served in the United States Navy from 1956 through 1961. He attended Ole Miss from 1965 through 1968, where he achieved a BA and then an MA in English. In 1970 Tom first had contact with the Catawba and he started his PhD studies. In 1976, the bicentennial of our country, Tom finished his doctorate and started working professionally with the Catawba Nation.

Tom's entire childhood was dominated by the church and this pattern continues to this day in his life in Lancaster, South Carolina. Tom's major identity is as a Roman Catholic and a Southerner. He has been to Rome five times and will most likely go there a few more times before he throws off this mortal coil. As for the fact that he identifies his life as that of a Southerner, it is true he was born in New York, but he is a Southern gentleman through and through and despises anyone calling him a Yankee. Having lived his entire adult life south of the Mason-Dixon Line, I have to agree: Tom is a Southerner.

Tom's first exposure to an American Indian was at Jones Beach, which is not too far from Freeport, where he had the bliss of listening to Princess Rosebud tell Indian stories. Her stories are lost to time, but when asked, Tom describes her as "the most beautiful woman that I had ever seen up to the age of five." Tom's library of his youth included a little picture book entitled *Indians of America*. He would spend hours dreaming over the pictures on each

Foreword

page and this is part of the core of Tom's love for the Native Americans. As a matter of fact this very same book can be found in the Blumer Archives along with all of Tom's other books and papers, located at the University of South Carolina, Lancaster.

Fast forward now to the early 1990s. Tom Blumer was appointed as the official Catawba Tribal historian, a position that lasted until 1998, when Tom left in protest to questionable tribal financial policy that he felt was leading to a disaster for the tribe. During the five years that he held this position, however, he wrote numerous short articles for the Catawba Cultural Center's newsletter. He also gave numerous historical and cultural lectures in the Cultural Center and at the Schiele Museum in Gastonia, North Carolina. Tom was also a regular speaker at the Yap Ye Iswa Catawba Festival. Since all of these duties fell away with his resignation, he looked for a way to stay in touch with the Indians who he served and loved. He had found what he was seeking with *The Herald* newspaper of Rock Hill. He contacted Mr. Terry Plumb and worked out a contract where he wrote a weekly column that appeared every Thursday. Since Tom has long lived and breathed Catawba history, coming up with weekly topics did not present a problem. Tom documents everything and many times he turned to the past transcripts of his weekly radio program that he had done for WFRM radio's *Smoke Signals*. Often he would use the information that he had gathered during his taped interviews with various Catawba personalities. In any case he would sit down every Friday and prepare for the following week's column. His goal was both simple and noble: to give to the Catawba people information about themselves that otherwise might have been lost to history. His only hope was to enrich the tribe through his efforts and I believe he has done just that.

Although what is before you has been rearranged in chronological order and the articles themselves have gone through a few revisions for content, what remains are the articles that had appeared in the Rock Hill *Herald*. It is the author's hope, and mine as well, that the reader will put this book down with a broad knowledge of the rich Catawba history and culture. This book is meant to be only a jumping off point in one's educational process. To take this knowledge several steps further, the reader may go on to Tom Blumer's bibliography, which has a very comprehensive treatment of written Catawba sources. One may choose to read Douglas S. Brown's *The Catawba Indians: People of the River*. Another must-read would be yet another Tom Blumer book, *Catawba Indian Pottery: Survival of a Folk Tradition*. This book is arguably the Bible of Catawba pottery tradition. One may choose to visit the Blumer Catawba Indian Nation Archives at the University of South Carolina, Lancaster. Almost everything ever written about the Catawba may be found there. It is a treasure.

Today the Catawba Nation numbers about 2,200 persons. The tribe is centered on its York County, South Carolina reservation, which lays about eight miles east

Foreword

of Rock Hill and some twenty miles south of Charlotte, North Carolina. Other Catawba who are not on the official tribal roll are scattered in Oklahoma, Texas, Colorado and Utah, to name just a few states. This makes the Catawba Nation a Native American group of considerable size. The Catawba's greatest significance is that they are the only Native Americans east of the Mississippi River who have maintained their pottery tradition in an unbroken line of succession from pre-Columbian times to the present. Indeed, it seems that the Catawba tradition may be the oldest in the continental United States, and can be carefully traced back from circa 2400 BC.

The Catawba are barely known in the Native American history, due to the fact that they alone stayed behind in the Carolinas following the notorious Trail of Tears. Most books that deal with the Native Americans of Dixie either ignore the Catawba or relegate them to a few sentences. This is an oversight that desperately needs correcting for the sake of accurate history.

Although the Catawba were known to a few educated and aware South Carolinians much earlier, the tribe was officially "discovered" by anthropologists in 1884. It was at this time that Dr. E. Palmer visited their reservation to collect some notes on aboriginal Americans. The notes are now sadly lost to history. The next scholar to visit the Catawba was Dr. M.R. Harrington, who made the trip from Washington, D.C., to the reservation in 1908. He was dispatched from Washington on a "fact finding" mission. The result of his effort was his small but important *The Catawba Indians*, published in 1909. A trickle of interest followed, but nothing monumental. Today this trickle has turned into a torrent of sorts, and I hope this small academic avalanche will help to put this most important Native American group into the proper status that it so richly deserves. The Catawba as a nation and a people are a treasure to be preserved for the sake of all Americans.

Robert Patrick Smith
Director/Videographer—Big Head Turtle Productions
A Native American video preservation project

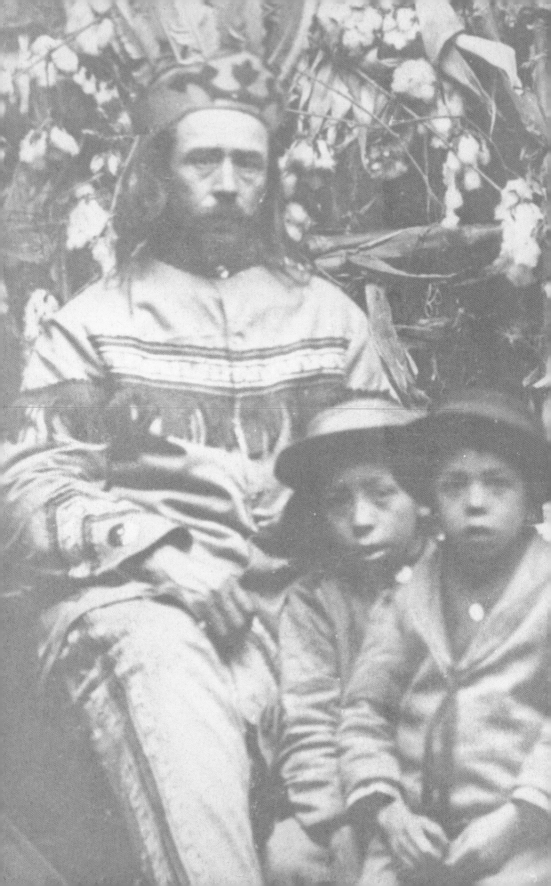

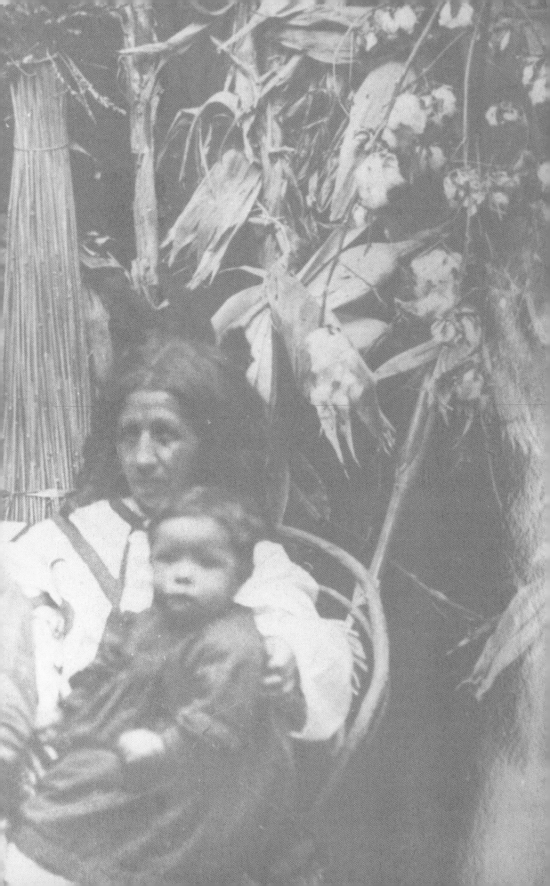

Catawba-Spanish Contact 1521

The clash between Stone Age America and Iron Age Europe is a topic of much discussion. On this continent we begin counting our New World time with Columbus, but the American Indian, including the Catawba, had no such need. Today the Catawba are thought by scholars to be the aboriginal people of the Carolinas.

We have no idea when the news of Columbus's arrival reached the Catawba. The news must have shot across the Caribbean Sea as fast as a traveling Indian canoe. The ancestors of the Catawba were apparently totally unprepared to greet the Spanish, then the French and finally the English explorers and colonists. The Europeans called the Indian situation primeval innocence.

Today we must go back to that first moment in history when the two cultures met. We must understand what went through the minds of the Indians who looked across an always-empty sea to find foreign vessels on the horizon. The startled Indians did not even have a name for the phenomena before their amazed and curious eyes. Their records are scant at best. On our side of the scene, the Spanish recorded what they were thinking. They had nearly despaired of seeing land. For the Europeans, the thought of finding a resting place with the promise of fresh water was the ultimate prayer. For the Indians, expecting nothing, they had thoughts of a different nature. They were on familiar turf and gazed at the strangers, confident that they had the upper hand. The Catawba were paramount in their territory; even the powerful Creek feared contact with these mighty warriors.

To get close to the Catawba contact experience, we must visit Yuchi folklore. The Yuchi, Catawba neighbors and perhaps allies, were living on the coast, apparently near modern Savannah, Georgia. Living in a buffer zone between the two powerful nations, we do not know if this small tribe was tributary to the Creek or the Catawba. Today the Yuchi live incorporated with the Creek Nation of Oklahoma. In any case, the Yuchi saw strange ships on the sea.

The Yuchi thought the ships, with their wind-propelled sails, were ocean birds. When the white men emerged from the surf, the Yuchi thought they were seagulls born of the sea's foam. Deceit was not expected.

The two, Indian and white man, stood amazed and pondered each other on the beach. They could not converse and resorted to awkward hand and body signals. As the Yuchi tale goes, the white strangers left only to return again for soil samples. They returned for the third time and wanted land on which to grow food. The saga of the invasion had begun. To the unsuspecting Indians, land was not a commodity, for it belonged to all men.

Leaving the Yuchi legend, history tells us that the Catawba first saw the European strangers and their amazing ships in 1521. Two Spanish slave ships belonging to Vasquez de Ayllon appeared off the coast of Chicora (Cofitachique), modern South Carolina. The Indians flocked to greet the strangers and to examine what they brought from their mysterious world. The Indians marveled at the size of the vessels made, not of one, but of many logs. Up to this time, the Indian experience included the dugout canoe only. True, one of these canoes could accommodate up to fifty men with paddles and twenty-five to thirty passengers. The Indian canoe was well carved but a primitive craft when compared with a Spanish galleon. The Indians immediately recognized the superiority of metal tools over stone. The wonders arriving with the Spanish ships were many. The Indians let their guard down. They were, after all, on their turf. The Spanish were vulnerable strangers.

The Spanish appeared friendly to the Indians and were generous with small gifts. By gesture, they invited the growing crowd of Indians to board their mysterious vessel. The curious Indians liked the idea of an entertainment; after all, learning is a passion common to all men. They would experience the wonders of the strange vessel and return home to tell the tale. More than one hundred Catawban speakers took the bait and boarded the vessel. To the Indians' surprise, the Spanish quickly raised their anchor and set sail with their unwilling human cargo. The destination was the young Caribbean colonies established by the Spanish.

These innocent souls fell victim to the first Catawba contact experience. Trapped far from shore, some refused to eat and starved to death. The two vessels experienced hard weather and one sank. Half of the captive Indians died by drowning in this tragedy. Those who lived to see the Spanish colonies led lives of misery so shocking that the Spanish Crown insisted they be returned to Chicora.

Only one man was fortunate enough to see his home again. He was baptized as Francisco of Chicora. Francisco became key to the Spanish plans to plant a colony at Chicora. He was taken from the Caribbean to Spain and trained as a translator for Spanish/Catawba relations.

Ayllon, accompanied by Francisco, returned to Chicora in 1526 with the purpose of planting a colony there. To the Spaniard's surprise the Indians fled when his ships arrived. Convinced that he faced only a temporary problem, Ayllon landed and began his colonization effort assisted by his trusted translator and servant, Francisco of Chicora. When the first opportunity presented itself, Francisco fled into the forest and was never seen again. Ayllon's colony was a dismal failure.

Catawba-Spanish Contact, 1521

We have no idea what became of Francisco of Chicora. Since he had spent several years in Spain, he was knowledgeable of European ways. We can only imagine Francisco heading straight for the Indian emperor at Chicora (Cofitachique), his goal to inform his monarch of all he had learned.

It was many years before the Spanish returned to make another colonization attempt among the Catawban-speaking Indians of South Carolina. When the Spanish finally made a foothold on the Carolina coast, the Catawba had no romantic notions about these strangers or the amazing gifts they brought.

Originally published as "Catawba meet the Spanish in 1521," *The Herald*, August 12, 1999.

Chicora, Cofitachique or Yupaha

Soon after Hernando de Soto began his journey across the American South, he began to hear rumors of a legendary land, always outside of reach. Earlier explorers who had touched the eastern coastland of the continent called this place Chicora. Between 1521 and 1540, the land had changed names to Cofitachique. This place became de Soto's goal.

When de Soto visited the Apalache in a land that later came to be known as Georgia, the rumors about this land grew in intensity. During this period, de Soto got lucky. One day an Indian youth appeared in his camp. The youth had spent time with an Indian merchant who knew the region and had visited Cofitachique to trade. The young fellow was called Pedro. The most interesting information Pedro provided the Spanish concerned an el Dorado to the north. The place was famed for its gold, silver and pearls. The Muskogee speakers of Georgia called the place Cofitachique. The term is a Creek word, in keeping with the Creek who dominated the area de Soto found himself in at the moment. De Soto was to learn later that in the language of the Catawban speakers who lived there, the place was called Yupaha. De Soto, operating through greed, quickly abandoned Apalache and headed north through Creek country. He was determined to reach two goals: peace with the Indians and possession of Cofitachique's treasures.

As de Soto's army inched its way north, the Indian diplomacy held sway. Rather than fight, the Indians generally approached de Soto in friendship. All along the way de Soto declared his friendship and told his informants that he was seeking Cofitachique, a land none of the Creek ever dared to enter. De Soto's hosts were faced with supporting a large army of Europeans. De Soto at this point had over 1,000 men and 250 horses, not to mention his growing herd of hogs. The Indian response was to be rid of de Soto as quickly as possible. By this time they knew his greed all too well and always pointed him to the north and away from their territory.

Eventually, de Soto reached Cofaque, a chiefdom adjacent to Cofitachique's southern border. The Indians of Cofaque (probably part of a Creek confederation), though they had never visited Cofitachique, lived in a constant state of war with the fabled chiefdom to the north. So eager was the ruler of Cofaque to seek vengeance

among his enemies beyond the Savannah River that he sent eight thousand men as guides with de Soto. The Cofaque men carried a huge food supply with them, as they were ignorant of what they would find beyond the Savannah. The Cofaque and the Cofitachique were separated by a very wide uninhabited buffer zone between the two chiefdoms. After a week of wandering through this area, de Soto and his Cofaque allies began to reach villages loyal to Cofitachique.

Operating on the ancient rule of vengeance, the Cofaque, unbeknownst to de Soto, sacked this village. They desecrated temples and carried off any riches they could wrest from the vanquished Indians. They also collected scalps. When de Soto discovered this deception, he loaded down the Cofaque war captain, Patofa, with gifts of fabrics, knives, scissors and mirrors and sent him back to the chiefdom of Cofaque, south of the Savannah River.

The Spanish continued their earnest search for Cofitachique. On May 1, 1540, de Soto's men reached a wide river. The legendary town of Cofitachique lay on the opposite bank of the river. Pedro, a Spanish soldier who knew some of the Indian languages, shouted across the river explaining that de Soto came in peace.

In time a large canoe appeared on the opposite bank. It carried six noble ambassadors, all elegantly dressed. It is possible that at least some of these men held the high rank of war captain. Once they reached shore, they disembarked and made ceremonial rituals of respect and saluted in the four cardinal directions. The men explained through interpreters that the chiefdom was ruled by a lady. They had little food to share since the chiefdom had recently suffered a pestilence, probably as result of the disease brought to America through the Spanish colonies established in the Caribbean. De Soto repeated that he had come in peace.

Satisfied with de Soto's response, the Indian ambassadors returned to the town on the opposite bank. In a short time, two large canoes appeared. The first was filled with men who held large paddles. The second was a state canoe, covered with a rich canopy and decorated with fine cushions. Eventually a lady, accompanied by eight serving women, boarded the canoe. A convoy was formed, led by the ambassadors. This canoe was followed by a vessel that carried the men with paddles who towed the royal canoe across the river.

The royal woman showed no sign of fear but approached de Soto with the confidence that suited her position. She alone spoke. The Spanish were amazed by her graceful charm and elegance. She knew that such a large army required food and offered part of what corn her people held in storage.

As the Lady of Cofitachique spoke, she slowly removed a long strand of fresh water pearls that circled her neck three times and hung to her thighs. She asked de Soto's translator to present the pearls to de Soto. She feared that if she presented the pearls herself it might seem immodest. In return, de Soto gave his royal greeter a gold ring set with a ruby.

Catawba Nation

Once the army was stationed in Cofitachique, de Soto spent his time exploring. The Lady of Cofitachique was shown samples of gold and silver and asked if her chiefdom produced such minerals. To de Soto's dismay, he was presented with copper, which glistened like gold, and iron pyrite, which had silver color but was not precious. The Spanish were not, however, disappointed by the pearls they were able to collect from various temples. De Soto's men found so many pearls that they could not carry them away.

De Soto left Cofitachique on May 13, 1540, still in search of the legendary riches he did not find among the Catawban speakers of Cofitachique. Forgetting his gratitude, de Soto forced the Lady of Cofitachique to join him in his march west as a hostage.

Today we know the site of Cofitachique was near modern Camden. It was the ancient seat of power for the Catawba. The Catawba did not abandon its ceremonial center until after the Treaty of Augusta (1763). For many years after this treaty was signed, the Catawba potters returned to a place they called Pine Tree Hill (Camden) to dig sacred clay.

Originally published in "De Soto Meets the Lady of Cofitachique," *The Herald*, March 23, 2000.

Juan Pardo and Cofitachique or Canos

A concentrated effort to colonize Cofitachique, called Canos or Canosi by 1565, began with the founding of St. Augustine. The genius behind this movement was a man who worked for the Spanish crown, Pedro Menendez de Aviles. Menendez's first task was to end French interests in the Southeast once and for all, and he did this with a vengeance. A second part of Menendez's vision was the founding of Santa Elena on the Carolina coast. Once this was accomplished, Menendez sent Captain Juan Pardo to Santa Elena with over one hundred men. He was given a rather incredible order for this small force and for the distances involved. Menendez had an ulterior motive. Silver had been discovered in Zacatecas, Mexico, and the village immediately became a center of frenzied activity as both Spaniards and Indians flocked there to cash in on the money that flowed from Zacatecas.

Menendez had a novel idea. He wanted to discover a road from Santa Elena in the Florida colony to the fabled Zacatecas, Mexico. It made no matter to Menendez that the distance this road would cover would exceed 1,700 miles through uncharted territory. This impossible assignment went to Captain Juan Pardo, who marched off into the Backcountry with a band of 120 men. If Juan Pardo's road assignment was not enough, in the process he was to pacify and evangelize the Indians and bring them into the Spanish king's domain.

Juan Pardo's progress was recorded by his journalist, Juan de la Bandera, who left a record of Pardo's two failed expeditions. Father Sebastian Montero was also a part of the explorer's team.

Juan Pardo's progress has been charted by Charles Hudson. He went through the heart of Cofitachique, or Canosi, the Catawba Nation. They visited some of the towns visited over twenty years earlier by Hernando de Soto. Recently, Blair Rudes, an expert on the Catawba language, studied the place names of all those villages visited by Hernando de Soto and Juan Pardo. To the surprise of everyone interested in the Catawba, most of these villages still had Catawba names.

The only dramatic but short-lived progress was made by Father Montero, who spent several years with the Catawban speakers of the Wateree Nation, who Montero knew as the Guatari. When Montero arrived, the nation was ruled

by two women who accepted Montero. He taught the Indians Spanish, with a concentration on the most influential Wateree, who visited him daily for lessons. In one report it is stated that the Wateree learned basic Catholic prayers, including the Our Father, Hail Mary, the Apostles Creed and the Salve Regina. The Indians also attended Mass on holidays and fasted from meat on Fridays.

Juan Pardo made two expeditions into the Catawba territory, built a string of forts and left them garrisoned by his men. No road to Zacatecas was found. Indeed, his explorations only crossed the Catawba Nation and reached into Cherokee-held territory. By March of 1568, Juan Pardo's work was done, but Father Montero stayed on among the Catawba until 1572. At this time, ill health necessitated his return to Spain. The Wateree mission was abandoned.

First Tuscarora War

1711-1712

The Tuscarora War of 1711–12 had several causes. The Indians objected to the settlement of New Bern, North Carolina, in 1710. The Indian traders also cheated the Tuscarora regularly. The last straw was the ill treatment of intoxicated Tuscarora by a settler. Seneca agitation also pushed the Tuscarora toward a major confrontation with North Carolina. The events of autumn 1711 were not spontaneous.

The carefully planned attacks occurred at dawn on September 22, 1711. More than 130 settlers died in the first hours. The survivors fled to Bath and New Bern. Other places were quickly fortified. During the nearly four months it took North Carolina to muster an army, the Tuscarora scoured the countryside, plundering and killing at will. Some unfortunate settlers were taken captive and subjected to traditional methods of torture.

Eventually North Carolina's appeals for help were answered. South Carolina sent an army led by Colonel John Barnwell. It consisted mostly of Indians: the Yamassee, the Catawba and their allies. The Catawba were interested in settling an old grudge with the Tuscarora and were easily lured by the promise of Tuscarora slaves, scalps and booty. It is thought that the Catawba remembered that the Iroquois-speaking Tuscarora had pushed into Catawba territory and occupied central North Carolina in recent memory. This tribal movement occurred before the arrival of the white man in the fifteenth century and was perhaps a general migration of the Iroquois to the south.

Barnwell was forced by circumstances to take a roundabout route to the war front in an effort to gather recruits among the Catawban speakers. He headed from Charles Town up the Santee River to the Congarees and the Waxhaws. All along the way, friendly Indians joined his army. Successful in recruiting, Barnwell left South Carolina with 30 whites and more than 500 Indians in mid-January 1712. Some 350 of Barnwell's army consisted of Catawba, Cheraw, Wateree and other Catawban-speaking Indians allied to the Catawba.

Catawba Nation

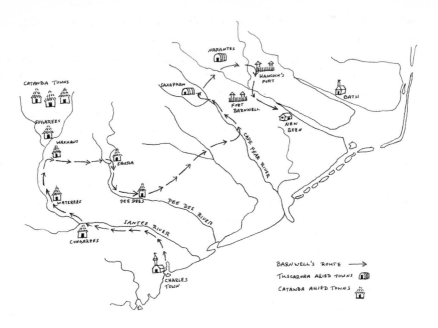

In the First Tuscarora War, Barnwell's route through the Catawba Nation where he recruited Indian warriors is well marked. When he felt that he had exhausted the possibility of Catawban recruits, he headed north to the Tuscarora Nation. *Illustration by the author, drawn from "The Journal of John Barnwell,"* Virginia Magazine of History and Biography *(April 1898)*.

The Catawba and their allies went off to war in the traditional way. The women combed their men's hair with bear grease and red root. The men's ears were decked out with feathers, copper, wampum and even entire bird's wings. The men painted their faces with vermilion. Often one eye was circled in black paint, the other in white.

War dances were performed, and the men set out looking as fierce as possible. Many did not own guns and proudly carried bows of their own making. In full traditional battle attire, the Catawba must have been an impressive sight. The name of the Catawba war captain who led the nation on this expedition is lost to history. None of the Indians would enter a war party without the urging of a powerful war captain who had won the right to carry snake images on his person in paint or tattoo.

Though the Catawba and their Catawban-speaking allies were propelled into this war by their hatred for the Tuscarora, their zeal for battle quickly waned. The Indians were more used to quick hit-and-run raids, simple revenge-seeking expeditions. Travel between the Waxhaws and the Pee Dee River was rough. The swamps were swollen with water. Some Indians lost interest and returned home. Others left when Barnwell crossed the Cape Fear River and entered Tuscarora

territory. Many of Barnwell's recruited Indians feared going openly into unknown territory and the consequences of being hemmed in by the Tuscarora territory they did not know. Escape would have proven difficult. Such a bold invasion was contrary to traditional Indian warfare, which was based on stealth, speedy attack, ambush and a safe retreat.

The first battle the Catawba experienced was at the fortified Tuscarora town of Narhantes. Even the Tuscarora women fought with the bow and died in battle. Barnwell lost no Catawba men but noted that six were wounded.

When Narhantes fell, the remaining Catawba and their allies took as many surviving Tuscarora captive as they could find and disappeared with them. They headed for the slave markets of Charleston. By the end of February 1712, Barnwell's army consisted of 94 whites reinforced by North Carolina settlers and 148 Indians, mostly Yamassee.

On March 1, 1712, Barnwell entered Tuscarora King Hancock's town. It was deserted. By March 5, Barnwell was before King Hancock's fort and laid siege to it. The Tuscarora threatened to torture white captives within Barnwell's sight and a truce was agreed upon. The Tuscarora and Barnwell agreed to a conference at Bachelours Creek on March 19. The Tuscarora did not show up. Barnwell's reputation continued to slip from this point until his return home to South Carolina.

Desperate for reinforcements, Barnwell asked the Catawba and their allies to return to help him take King Hancock's fort. The attack began on April 7, 1712, and lasted ten days. Again, Barnwell was cheated out of his Tuscarora slaves by his Indian allies, who quickly gathered survivors and headed for Charles Town's slave markets.

Disappointed but determined to turn a profit, Barnwell lured Indians into Fort Barnwell on the pretext of a meeting. Once inside the fort, these unfortunate souls were held captive and shipped off to Charles Town. Barnwell would have his profit in Indian flesh come what may.

The result of this short but violent war was that even the friendly Indians of the Carolinas lost confidence in the Christians. The historical lesson of 1521 had repeated itself. The Tuscarora began their flight north to join the Iroquois Confederation in what is now New York State.

Once safely welcomed by their Iroquois kinfolk, the Tuscarora fanned the fires of hatred between the Iroquois and the Catawba. Iroquois war parties headed on the path to the Catawba Nation with greater frequency.

The Tuscarora War of 1711–12 was so poorly handled by Barnwell that the Second Tuscarora War followed within two months.

Originally published as "Catawba Get In On the Fight," *The Herald*, January 13, 2000.

Second Tuscarora War

1712

Colonel John Barnwell's contributions to the Tuscarora situation in North Carolina were mostly negative. Although the Tuscarora continued to ravage the countryside, the Indians were convinced their plight in North Carolina was hopeless. After the Barnwell expedition's failure, the Tuscarora began their migration north to join the Five Nations in New York. Barnwell's inability to make peace with the Tuscarora put North Carolina at risk. Many settlers were willing to abandon the colony.

After Barnwell's campaign, the fearful settlers continued to live behind stockades but did little to help themselves. The colony made feeble attempts to gather an army. In June 1712, a North Carolina delegation once again asked South Carolina for assistance. Colonel James Moore set off in October 1712 from Charles Town to North Carolina to gather an army of Indians. He negotiated with the same Catawba allies Barnwell had approached in 1711. After Barnwell's deception, Moore's recruiting was rather slow. Rather than halt at the Waxhaw Town, he marched north to the Catawba towns, presumably to coax the Catawba directly. His first task was to convince the Catawba war captains that a war against the Tuscarora was to their advantage. This was done in a traditional Indian congress. Once the war captains agreed, they began the war ritual. Each took up a pot drum and danced counterclockwise around his house, performing a call-to-war song. When a crowd of men gathered, the war captain recited the crimes of the Tuscarora against the Catawba. Then the war captains and their men fasted for three days. They purged their bodies of impurities with the powerful emetic button snakeroot. Until the end of the campaign the men had no relations with women; however, women were suitable victims of scalping. The scalp of any enemy, including man, woman or child, was an acceptable trophy.

Colonel Moore crossed the Cape Fear River with 500 Catawba and their Catawban allies, 300 Cherokee and 50 Yamassee; 33 whites led the force. They joined 140 members of the North Carolina militia.

The situation in North Carolina remained critical. The settlers feared the Five Nations would join the Tuscarora. But some Tuscarora towns remained neutral.

Second Tuscarora War, 1712

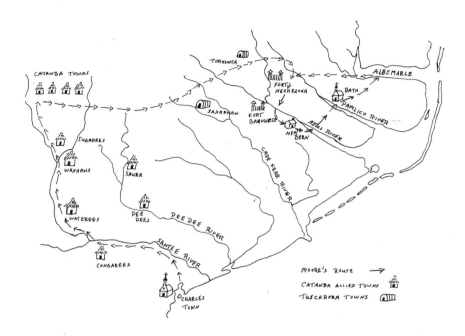

Above: At the beginning of the Second Tuscarora War, Moore followed much the same route through the Catawba Nation that Barnwell had taken earlier. His goal was to pick up Catawba recruits as he visited one Catawba town after another. *Below:* Moore's battle plan for the fortress at Neoheraka, Tuscarora Nation. Taken from Moore's original battle plan, which shows the position of the Yamassee and Catawba troops. *Illustrations by the author.*

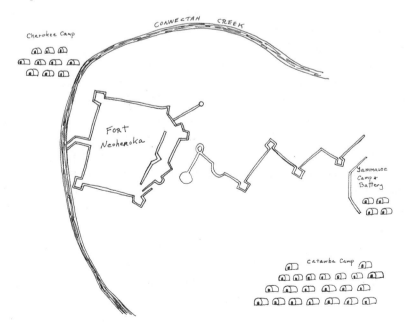

Tuscarora King Blount delivered the renegade King Hancock to the North Carolinians; Hancock was executed for promoting the rebellion.

Rather than go into the heart of the Tuscarora Nation, Colonel Moore marched through New Bern, to Bath and finally to the Albemarle. There he stayed with eight hundred hungry Indians and no provisions. The Catawba, Cherokee and the Yamassee, following Indian tradition, helped themselves to cattle and other food they could take from the settlers.

While this lack of organization continued, the Tuscarora had time to strengthen Fort Neoheroka. The fortress consisted of 1½ acres, fully palisaded along modern lines. It was defended by bastions and blockhouses and had water inside. The Indians built strong houses and dug caves. The plan for Moore's successful siege and attack survives in a diagram that shows the positions his men took outside the fort's confines.

Fort Neoheroka fell on March 20, 1713. A total of 475 Tuscarora were killed and scalped. Another 415 were sold into slavery. Others fled north to the Five Nations. King Blount became ruler of the Tuscarora, who stayed in North Carolina. Some hid in the Great Alligator Swamp and continued guerrilla raids for years after.

The Catawba returned to their homes triumphant. Their goal had been to obtain Tuscarora scalps and slaves in vengeance for past Tuscarora crimes. History tells us nothing of the fate of the Tuscarora slaves, but the Iroquois were not finished with the Catawba.

The Catawba had many scalps to adorn their homes and placate those killed by past Tuscarora raids. The men danced, holding pine branches decorated with scalps. The war captains held their share of the bloody trophies aloft. The rank of each war captain depended in large part on their ability to take scalps from the enemy. These triumphant men stood in their council houses and gave long speeches telling of their strength in battle. Songs were composed and sung. Men holding pot drums chanted while women standing in long rows did the victory dance. The Catawba had shown themselves to be great warriors.

Unfortunately, vengeance was crucial to Indian warfare. Although the Tuscarora had fled, they knew the warpath from the Five Nations to the Catawba Nation. From 1715 until the final peace between the Catawba and the Iroquois (by this time called the Six Nations) was negotiated by Catawba King Haigler in 1751, the Catawba paid dearly for their participation in the two Tuscarora wars. These wars intensified the murder of Catawba tribal members of all ages and both sexes. Revenge did not require the death of only men. A woman caught drawing water from a spring or a child who wandered from the camp fulfilled the demand for blood. From the Six Nations in New York to the Catawba Nation, no one was safe.

To this day, the Tuscarora remember their flight to join the Iroquois as well as the Catawba role in their humiliation.

Originally published as "Catawbas Mix Again with Tuscaroras," *The Herald*, February 17, 2000.

The Yamassee War 1715-1716

The Catawba were key to the Yamassee War in the Carolinas, since they are recorded as being the largest nation, with 570 warriors. By comparison, the Yamassee who started this conflict only had a little more than 400 warriors on record. With their Catawban-speaking allies, the Catawba numbered far more fighting men. All the Catawban-speaking groups in both Carolinas joined this effort to expel the Europeans from the Southeast.

No Indian war ever exceeded the Yamassee War in its widespread scope. Geographically, the war spread from the Cape Fear River in North Carolina to the St. Mary's River in Florida and west to the Alabama. The Indians had numerous grievances against the white settlers. These included abuses of a cruel and obscene nature committed by the white traders who worked among the Indians. Abuses such as murder and rape were common. If needed, they would help themselves to the Indians' crops and not pay for this food. In addition, the traders fomented Indian wars to foster the Indian slave trade. Other grievances included white settlements that encroached on Indian land. The settlers refused to see their role and sought blame for the tragedy. They found an easy target in the Spanish of St. Augustine and the French in Mobile. In truth, the powerful Creeks instigated the war, but the Yamassee dealt the first blow. It is thought that the Yamassee were Creek speakers.

South Carolina's lamentable role was outlined by Dr. Francis Le Jau of Goose Creek, who knew the Yamassee and saw the problem coming. He pointed an educated finger at his state of South Carolina. Some authorities in Charles Town tried to stop the abuses. The Indian Act of 1711 was passed in an effort to make things right, but the abuses were too accepted and too widespread. Part of the problem was the white man deceiving the Indians and getting them drunk to purchase land from them, the sale of free Indians as slaves and the highhanded conduct of the traders who worked in the Indian towns.

So widespread was the Indian sentiment against the settlers that virtually every Native American community joined the war effort. The Catawba were supported by the Cheraws, Santees, Congarees and Corees, to name only a few of the tributary tribes. Naturally, the Tuscarora, remembering their two wars of recent years, were

included in the ranks of the fighting men who harassed the settlers. Some of the Cherokee joined the Catawba, but the Cherokee had political problems with the Creek. Only the Chickasaw stayed aloof and eventually protected Indian refugees fleeing punishment. Some of the Yamassee also joined the Creek at the war's end.

The Indians punished the traders first with the instant death of 90 percent of them. This happened on April 15, 1715. In the process, forty colonists were killed.

South Carolina was swift to muster an army under Captain George Chicken. The Indians suffered a defeat at Goose Creek, and the Catawba and their allies had second thoughts about the war. On July 18, 1715, the Catawba sued for peace. They were joined by the Cheraws and did something all too common in Indian politics: they offered to turn on the Yamassee and hence assist South Carolina. On October 18, 1715, a delegation went to Williamsburg, Virginia, for a peace conference. Not all of the principal men were at Williamsburg, and Governor Spotswood insisted that they return with all the Catawba chief men.

A second conference was begun at Williamsburg on February 4, 1716. Spotswood wanted the Catawba to deliver the sons of their headmen to Fort Christanna as hostages. These children would serve to keep the Catawba in line with the proposed treaty. They would also be taught English and the Christian religion. In July of 1716, the Catawba had a similar peace conference in Charles Town, South Carolina. By this time the Yamassee had been pushed south of the Savannah River and the war was basically over.

The Catawba children, eleven of them in all, were delivered to Fort Christanna, Virginia, in April of 1717 by Catawba King Whitmannetaughehee.

The end of the war came with the flight of the Yamassee to St. Augustine, Florida. Those who were not lucky enough to escape were sold into slavery in New England and the colony of Jamaica. Today the Yamassee are extinct as a community. It is thought that some of the Yamassee sought refuge with the Catawba; if this is true, their bloodlines must exist there and among other southeastern tribes, such as the Chickasaw and the Creek, who sheltered some of the Yamassee.

King Haigler (Nop-ke-hee)
circa 1700-1763

Nop-ke-hee was born around 1700 but we know nothing of his parents. Since Catawba kings were not elected in a straight line from father to son but from the king's sister's son, this kind of reckoning does not work. He was a head man and thus of the royal line, but that is all we can say with any certainty. At the end of Catawba participation in the Yamassee War, Catawba King Whitmannetaughehee delivered eleven boys from the royal line to the Indian school at Fort Christanna in Virginia. The initial request was made by Virginia authorities as insurance that the Catawba were sincere in their desire to escape the Yamassee War. Nop-ke-hee was possibly one of these children delivered in April 1717. This supposition is based on the fact that Nop-ke-hee was the right age and of the noble class to attend Fort Christanna under such a plan. He also knew some English, though he always refused to speak the language, preferring the use of a trusted translator.

By 1740, Nop-ke-hee was a headman among the Catawba and highly respected. His life changed dramatically in October 1750. At this time Catawba King Yanabe Yalangway (Young Warrior) traveled from the Nation to Charles Town for an official meeting with South Carolina's authorities. The meeting over, Yanabe Yalangway traveled back to the Catawba Nation with fourteen of his headmen. Just outside of Charles Town, the party was ambushed by Northern Indians (Iroquois) and all of them were killed. Only one headman was left to the Catawba Nation: Nop-ke-hee, who was out in the country hunting. The Catawba immediately sent runners out to find him and inform him that he had been elected king of the Catawba by the General Council.

Nop-ke-hee became known as King Haigler.

King Haigler quickly came to be honored as the greatest historical ruler the Catawba had ever known. He was noted for his negotiating skills, which he practiced on the authorities in Charles Town. King Haigler and the industrious Catawba potters saved the Catawba from extinction.

One of the first tasks King Haigler took on was the negotiation of a peace treaty with the Six Nations (Iroquois) of New York. The Catawba and the Iroquois had long practiced a war of vengeance between South Carolina and New York.

This genocidal activity was heightened following the defeat of the Tuscarora and their migration to New York, where they joined the Five Nations, forming the Six Nations. The Iroquois were much stronger than the Catawba and increased the number of their raids on the Catawba. It reached the point where the Catawba men feared to go out on hunting expeditions and leave their wives and children at home unprotected.

In June 1751 a Catawba delegation consisting of King Haigler, five headmen and a translator left Charles Town on board the HMS *Scorpion*. On June 7 the party arrived at Fort George in New York harbor, from which they began the dangerous trip into the heart of the Six Nations. On June 30 the Catawba reached Albany, New York, the location of the peace conference. The situation was so hazardous that King Haigler and his headmen had to be guarded from harm from Iroquois who did not want to see a peace made. That King Haigler might be kidnapped and forced to dance the Dance of Death was a great possibility.

The ritual treaty began as soon as the representative Mohawk arrived. The Mohawk demanded the Catawba make a show of humiliation and dance with their feathers pointing down to the ground. King Haigler agreed. The Catawba approached the Mohawk in full regalia, singing and dancing, feathers pointed toward the ground. While the Catawba headmen danced and sang to the sound of rattles, King Haigler prepared a peace pipe. He smoked it and gave it to Mohawk King Hendrick. What followed were formal speeches and the presentation of wampum. When the Six Nations presented the Catawba with a wampum belt, the peace was final.

In the fall of 1752, an Iroquois delegation visited the Catawba and was treated as friends. The bloodshed slowed down. The Tuscarora remained bitter, as did the related Shawnee. A prisoner exchange became problematic. Some Iroquois prisoners who had lived among the Catawba for many years did not want to go home. The same was true of some Catawba who had lived among the Iroquois. Some of the Iroquois prisoners were found and sent to Charles Town, where they refused, out of fear, to board the ship for their return to New York.

During this period, the Cherokee invited the Catawba to incorporate with them and King Haigler refused. His only son died and King Haigler constantly faced the problem of encroachments from white settlers. He relied on his brilliant diplomatic skills. He was the first Native American in South Carolina to talk against the evils of alcohol and begged the settlers to sell this damaging drink to their own young men, rather than the Catawba. He fought dual justice, that is to say one set of laws for the white man and one set for the Indians, a problem that still exists in South Carolina. He also defended women as valuable to every nation.

In 1756, King Haigler made a defense treaty with the colony of Virginia. Through all these problems Haigler's world was in rapid decline. He still maintained his residence at Pine Tree Hill, the ancient location of Cofitachique. He solved some of

King Haigler (Nop-ke-hee), circa 1700-1763

his demographic problems by allowing small former Catawban-speaking tributaries to incorporate with the Catawba. In 1759, half of the Catawba died of smallpox.

The second high point in King Haigler's career came when he negotiated the Treaty of Pine Tree Hill in 1760. The negotiations took three years. Haigler was willing to move his residence and the entire nation from Pine Tree Hill 70 miles to the north to the Waxhaw Old Fields on the banks of the Catawba River, about 16 miles west of what was soon to become the village of Lancaster. He was willing to cede most of his 55,000-square-mile land base, which he knew was lost to illegal settlement in both Carolinas. King Haigler's goal was to preserve as much of his ancestral lands as possible. The result was that Haigler kept two million acres of land in a 30-mile radius from his villages in the Waxhaw Old Fields. The land-hungry settlers grumbled, particularly those in North Carolina. The only part of the treaty that was kept was the Catawba responsibilities.

We will never know what truly happened on August 30, 1763. King Haigler was traveling from his chief town on Twelve Mile Creek to visit the Waxhaws. Legend has it that he was attacked by seven Shawnee, shot through with six bullets and scalped. This crime was committed a couple months before King Haigler was to attend the Treaty of Augusta in Georgia. The Catawba blamed the Shawnee and South Carolina was off the hook. We will never know the identities of those men who committed this crime. It is a fact that both Carolinas had an easier time negotiating with the Catawba without the brilliance of King Haigler present. An additional stroke of luck occurred for the settlers of the Carolinas: the text of the Treaty of Pine Tree Hill was conveniently lost. In 1979 the Catawba had trouble negotiating their settlement because of this loss. All attempts to find it came to nothing. The Catawba at Augusta were left powerless and with no legal leg on which to stand. The negotiations at Augusta were brief, handled by Colonel Ayers as regent. South Carolina had full advantage. Instead of 55,000 square miles, the Catawba land base was cut down to 15 miles square.

The last insult came at King Haigler's gravesite. His grave was reportedly ten square feet and ten feet deep. The Catawba respectfully filled Haigler's grave with all his worldly possessions, including many state gifts and items of great value. Sixteen Catawba guarded the grave. Some white men who were in the vicinity made the Catawba drunk and desecrated the royal grave. As a result, the Indians moved Haigler's body to a secret location.

Today the Catawba remember King Haigler in the King Haigler effigy pipe. The potters also make a plain elbow pipe with King Haigler's signature on it, a pattern of straight and curved lines.

Originally published as "King Haigler" on WRHI-FM radio in Rock Hill, South Carolina, June 1997.

Treaty of Pine Tree Hill 1760

The Catawba experience since European vessels appeared off the Cofitachique coast—now modern South Carolina—has not been pleasant. The news in 1521 of a Spanish arrival shot through the Catawba Nation with lightning speed. The coastal Indians wondered about the canoes built of many logs and propelled by the wind.

The bearded men seemingly came from another planet. The result of their arrival was the kidnapping of one hundred Catawban-speaking Indians for sale on the slave markets of the Caribbean. Lured on the vessels with friendship and gifts, these Indians found themselves bound for Cuba, where all but one died. And this crime was merely the beginning.

Other ships came and tried to plant colonies, but left in despair. When the English arrived in 1670, the fate of the Catawba Nation was sealed. At European contact, the Catawbas claimed a nation of some 55,000 square miles. Every settler who emerged from Charles Towne either took Catawba land or land owned by a tributary of the Catawba. By the middle of the eighteenth century, such encroachments had come close to the Nation's center.

Catawba King Haigler, the ultimate politician, knew that he could not hold his huge land base secure from land-hungry Europeans. Instead, he negotiated a deal that would accommodate the invading Europeans and hopefully protect his people. By 1760, these negotiations were ready for a final agreement in the form of a treaty.

King Haigler knew that Pine Tree Hill (once called Cofitachique and today called Camden) was no longer a viable capital for the Catawba Nation. He agreed to one of the first Indian removals in history. The Catawba were to abandon their ancient ceremonial center at Pine Tree Hill and retreat north to their sacred grounds at the Waxhaw Old Fields, on the western edge of Lancaster, South Carolina. In the treaty (the text is lost) King Haigler wisely reserved two million acres as a Catawba land base. In return, he abandoned his other lands, which included much of South Carolina and stretched through central North Carolina to modern Danville, Virginia.

Treaty of Pine Tree Hill, 1760

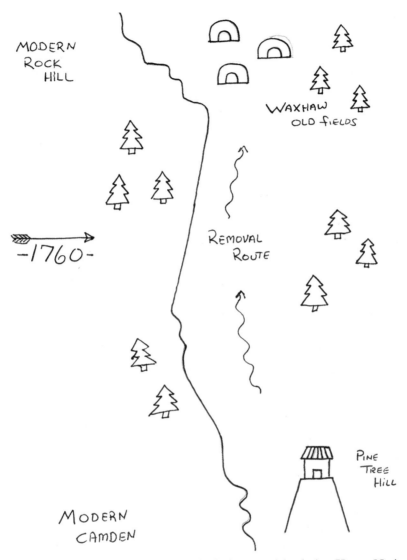

MODERN
ROCK
HILL

WAXHAW
OLD FIELDS

-1760-

REMOVAL
ROUTE

PINE
TREE
HILL

MODERN
CAMDEN

By the Treaty of Pine Tree Hill the Catawba surrendered title to most of their lands in Virginia, North Carolina and South Carolina. They kept control of two million acres centered in a circle around the Waxhaw Old Fields. According to this treaty the white settlers were supposed to vacate lands they were claiming, but this did not happen. The next treaty cut the Catawba land holdings down to even fewer acres. *Illustration by the author.*

Thinking the Indian way, he kept Catawba hunting rights to all of South Carolina. He believed that what the land produces is more valuable than the land itself. This lack of understanding of European thought patterns about land ownership has always been problematic in Indian-white dealings when land ownership has been involved.

Governor Bull of South Carolina also agreed to certain stipulations made by King Haigler. Bull promised to prevent white settlers from moving closer than thirty miles to any Catawba town. The treaty called for the forced removal of any squatters found within the Catawba boundary as well as the construction of a fort (now modern Fort Mill, South Carolina). On his part, Bull appeared eager to protect Catawba hunting rights within South Carolina.

The treaty was sealed the Indian way, with gifts. King Haigler received a gorget of gold, and his queen received a silver plate. Governor Bull took full legal rights to a huge area within South Carolina. Both North Carolina and Virginia did likewise. It is thought that these two colonies went unmentioned in the treaty.

As was usually the case with Indian treaties, the Catawba honored the treaty. They immediately abandoned Pine Tree Hill and migrated to the Waxhaw Old Fields. The Catawba naïvely expected South Carolina to keep its part of the agreement. The first objections came from Governor Dobbs of North Carolina. Though we know nothing of the treaty's impact on North Carolina, Dobbs felt that two million acres was too large a reservation for a nation as small in number as the Catawba.

In reality, settlers from North Carolina had already moved onto land reserved by King Haigler. South Carolina failed to evict squatters from the newly defined and much reduced Catawba land base. South Carolina dragged her feet on building the fort and it was not constructed until years later. As was customary, in proper season, Catawba hunters spread out across South Carolina. In violation of the treaty, the Catawba were attacked by bands of irate whites who beat them and stole their skins. The only stipulations found in the Treaty of Pine Tree Hill that were honored were the removal of the Catawba to the Waxhaws and the surrender of a huge land area by the tribe. When King Haigler was murdered in 1763, supposedly by a Shawnee war party, the fate of the two million acres seemed uncertain. The Carolinas could not have had better luck in the timing of King Haigler's death.

Unhappy with the tremendous victory signaled by the Treaty of Pine Tree Hill and hungry for more land, both North and South Carolina jockeyed for a new conference and treaty that would further reduce the Catawba land base. This happened through the Treaty of Augusta in 1763. It is interesting that when the Native American Rights Fund began its research of the Catawba land claim in 1979, the text of the Treaty of Pine Tree Hill could not be located.

One can speculate why such an important document recorded by the English, a people impassioned by record keeping, might be lost. As it stands, what little we know of this treaty is learned from secondary sources. If the document is ever located, it may shed light on Catawba claims to both North Carolina and Virginia.

Originally published as "Treaty Was One of Many Made," *The Herald,* June 24, 1999.

Treaty of Augusta 1763

Throughout the French and Indian Wars, the Catawba were increasingly alarmed over the creep of the white settlements toward their towns. At one point, North Carolinians were openly surveying Catawba lands for illegal possession. South Carolina protested, but the encroachments continued. During this period, Catawba King Haigler traveled to Charles Town to protest the settlers' movements.

The Congress of Augusta and the resulting treaty were caused by Indian unrest. The Catawba were deeply concerned about encroachments, and the other major Southern tribes had equally serious issues. The Congress was intended to calm Indian fears and set new boundaries. The Indians were always asked to surrender more of their ancestral land. The Catawba had already surrendered millions of acres in the Treaty of Pine Tree Hill (1760), but they had more land to give. They were to settle for less than the two-million-acre reservation outlined in 1760. The Catawba sought to keep a land base in the Waxhaws.

In 1763, plans were made for a Congress to include all the principal Southern Indian nations, including the Catawba. In June 1763, King George of England issued a proclamation reminding the colonies that only the British Crown could authorize the purchase of Indian land. This document was ignored by the land-hungry settlers.

Augusta, Georgia, was the chosen location for the Congress. The settlement was free from smallpox and acceptable to the Indians. Money was appropriated to supply Augusta and provide the gifts crucial to negotiating with the Indians. Soon the authorities found that Augusta was inconvenient. The Savannah River was not easily navigable. Dorchester, South Carolina, was suggested as more suitable. This village was only 15 miles from the comforts of Charles Town. Augusta meant a trip of more than 140 miles over land. The passage from Charles Town to Savannah, Georgia, and then by river to Augusta was a daunting 200 miles. The Indians, reluctant to visit the settlements, refused to accept Dorchester.

A Catawba delegation of sixty men, women and children arrived at Augusta on October 13, 1763. They were quickly joined by Creek, Chickasaw and Choctaw.

Catawba Nation

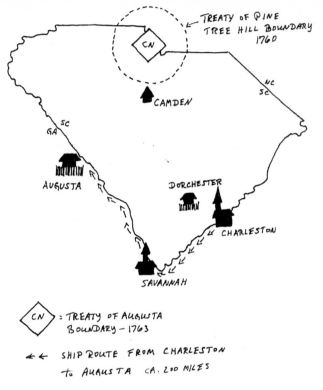

In the Treaty of Augusta the Catawba agreed to vacate more of their ancestral lands and reserve 144,000 acres centered in the Waxhaw Old Fields in an area that eventually came to be known as Lancaster County. *Illustration by the author.*

By the end of October a fearful Cherokee delegation arrived. Tensions were keen among the Indians. Shortly before, the Creek and the Chickasaw had been at war with the Cherokee. The Choctaw delegation traveled in disguise out of fear of the Creeks. Five hundred Indians encamped around Augusta. There was a great opportunity for vengeance.

The Catawba were led by Colonel Ayers, who served as regent following the untimely death of King Haigler on August 30, 1763. Colonel Ayers spoke English, and the Catawba were the only Indians not in need of a translator.

The Congress opened with the usual niceties. The English spoke of a lasting peace. They were willing to pardon the Indians for their past crimes. The English wanted easy trade and safe passage for authorized Indian traders. The English also spoke against horse stealing and killing cattle. Interestingly enough, offenders of the law, both white and Indian, were to be put to death for murder. The Treaty of Augusta announced a new era of Indian-white relations. It is doubtful that the Catawba had much confidence in such rhetoric. King Haigler had protested a dual justice system many times.

Treaty of Augusta, 1763

According to the treaty transcript:

> [Colonel Ayers] *always minds the White People. The King George's talk and four governors are all good. Today all the people meet here. He hears all the Red people and the White right well and they Talk good (gives a string of* [wampum] *beads). These are white beads all, none black, all for King George and the four governors. They all send a Talk a good Talk to the Red People. He and his People are as White Men and is well pleased with what he has heard. He did and will keep it to his heart. He goes to sleep and rises but never loses the Talk of the White People. The Catawbas are all of one mind…His Land was spoilt. He had lost a great deal both by scarcity of Buffaloes and Deer. They have spoiled him 100 Miles every way and never paid him. His hunting Lands formerly extended to Pedee River but is driven quite to the Catawba Nation.*
>
> *If he could kill any deer he would carry the meat to his Family and the skins to the White People, but no Deer are now to be had. He wants 15 miles on each side his Town free from any encroachments of the White People, who will not suffer him to cut Trees to build withal but keep all to themselves.*

Although Ayers made a ceremonial presentation of wampum, no mention is made of smoking the Catawba peace pipe.

The Treaty of Augusta contains only four articles and article four concerns the Catawba Nation:

> *And We the Catawba Head Men and Warriors in Confirmation of an Agreements heretofore entered into with the White People declare that we will remain satisfied with the Tract of Land of Fifteen Miles square a Survey of which by our consent and at our request has been already begun and the respective Governors and Superintendent on their Parts promise and engage that the aforesaid survey shall be completed and that the Catawbas shall not in any respect be molested by any of the King's subjects within the said Lines, but shall be indulged in the usual Manner of hunting elsewhere.*

The Treaty of Augusta had legal force for more than two centuries. It was a major document in the recent suit brought by the Catawba Nation against South Carolina and the United States government in 1979. By this treaty, the Catawba reserved 144,000 acres as their land base. The Catawba Nation had been reduced from 55,000 square miles in the sixteenth century to a small fragment of their former land holdings.

Originally published as "1763 Treaty Written to Settle Indian Unrest," *The Herald,* September 9, 1999.

The American Revolution Begins

The War of the American Revolution began as a movement of great confusion for the Catawba. For nearly two hundred years, the Indians fought beside the English settlers. The Catawba had protected South Carolina's western frontier from Indian attack. Earlier they stood loyally with the English in the French and Indian War (1754–63). It was unthinkable to the Catawba that a people long considered of one heart and mind would suddenly become deadly enemies.

The Catawba were ruled by King Frow, Haigler's legitimate heir. The first indications of trouble came in 1775. Rumor had it the American Patriots would kill all those loyal to the English. One sign the Patriots were to take as their own was the wearing of a deer's tail on one's hat or head. This talk, plus the settlers' war preparations, alarmed the Catawba. King Frow sent two runners to the Council of Safety in Charleston. The response they brought home was that South Carolina expected the Catawba to stand by the state. The Catawba were also asked to send a delegation to the Cherokee Nation and solicit their loyalty to the American cause.

Councilman Drayton, charged with securing Catawba loyalty, used the trade in deerskins as bait. He said that Great King George wanted to double the prices paid for goods through deerskins. Furthermore, evil men surrounding the king were sending Redcoats to take the Americans' money. Drayton sealed his negotiations by promising to pay the Catawba for their service. The first indication of Catawba loyalty came soon with the abdication of King Frow. He became the first Catawba Revolutionary War casualty.

Although the Catawba Nation became a republic, the new Catawba ruler was selected according to ancient tradition. This was done through the female rather than the male line. General NewRiver was chosen not on his own virtue alone, though he was a war hero of great merit. The key to his selection was his wife Sallie NewRiver, who was King Haigler's granddaughter. This little understood method of rise to power was followed by the Catawba until the Treaty of 1840, when the whole idea of generals as rulers was supplanted by the title of chief through a simple election.

The American Revolution Begins

During this period, the Catawba sent a delegation to nearby Charlotte, North Carolina, to learn more about the direction they should take. As a result, the Catawba were present at the signing of the Declaration of Charlotte. The die was cast. The Catawba would stand fast with the rebellious Americans. No matter what the western Indians might do, the Catawba would protect the South Carolina frontier from an attack through the back door.

The Catawba men prepared for war. War Captain Pine Tree George and the other war captains led in the traditional ritual and period of fasting. Speeches and war dances were held in the Nation's Council House. The women combed their men's hair with bear grease. The men decorated their hair with deer tails, which would identify them as loyal Native Americans. No one would mistake the Catawba men for loyal subjects of King George. Then the Catawba left for battle. In October 1775, some twenty-five Catawba men were paid ten pounds each for joining the American cause under Samuel Boykin's command. Four months later, in February 1776, Boykin led thirty-four Catawba men into South Carolina's Lowcountry to pursue, capture and return runaway slaves to their owners.

The major Catawba contribution to the early Revolutionary War years was their participation in the Cherokee War of 1776. Caught in the confusion over which English group to serve, the settlers or those loyal to King George, the Cherokee threw their lot in with the king's men. Twenty Catawba men joined Colonel Andrew Williamson in his August 1776 invasion of the Cherokee Nation. Again the Catawba wore deer tails in their hair to distinguish themselves from the Cherokee.

The war records are very sketchy, but it is safe to say the Catawba took part in most battles fought in South Carolina until the entire Catawba population and many of the whites fled north to Virginia. Upon their return, the Catawba men continued to serve the American cause. When Americans returned to retake South Carolina, the Catawba continued to fight in the war.

Two rosters survive from the period, giving us at least a partial list of over fifty Catawba veterans. One interesting story has survived. As veteran Peter Harris lay on his deathbed, years after the Revolutionary War had become a dim memory, Peter Harris told his longtime friend James Spratt of a deed he had committed that lay heavily on his conscience. It was in August of 1780 as the British under Cornwallis terrorized the Catawba Nation and surrounding area. Peter was angered by the barbarity of the British at the Waxhaw massacre and the treacherous murder of his old friend, Samuel Wyly. Harris came upon a British soldier who had put his gun down to drink from a stream. Peter shot and killed the defenseless man. Years later, Peter felt ashamed of what he considered a cowardly act.

Originally published as "Catawba Had a Role in America's Fight for Independence," *The Herald*, March 2, 2000.

Catawba Patriots Flee to Virginia

The Catawba have participated in wars fought on these shores for untold centuries. Naturally, the Catawba men were quick to assist their non-Indian neighbors during the Revolution. The Catawba battle sacrifices were long and filled with drama. Unfortunately, often Catawba contributions remain undocumented. Several episodes stand out as worthy of discussion. The tribe's 1780 removal from South Carolina to Virginia is one such event.

The summer of 1780 was filled with action that threatened the Catawba Nation. It began with the massive surrender of Charleston to the British forces in May of that year. At this point, the only hard resistance in South Carolina to a total British occupation was located in the people stationed right below Charlotte, North Carolina. This stubborn resistance was centered on the hearty settlers who had gathered near the Catawba Nation's 144,000-acre reservation. The British were well aware of the sentiments in this area and headed from Charleston's environs in the direction of the Catawba Nation.

The most frightening event was the British massacre of American troops who were under a flag of surrender at the Waxhaws on May 29, 1780. The Catawbas, who understood battlefield cruelty only too well, were uneasy that this massacre had occurred so close to their towns.

As the British worked their way inland, Camden seemed doomed to British occupation. The Catawba towns would then be within easy reach. The Catawba fought at Tuckasegee Ford in June, Flat Rock in July and Rocky Mount and Hanging Rock in August. Camden fell to the British on August 16, 1780.

This British success was quickly followed by the murder of Samuel Wyly, an old friend of the Catawba. Wyly had surveyed the 144,000-acre reservation, traded with the Indians and was respected by the Catawba. Following the fall of Camden, there was a general population stampede from the Carolina Upcountry, led by American General Gates. He was frantic to escape the British. Fortunately, the Catawba men were close to home and ready to protect their women and children.

The final event that caused the Catawba to join in the panic and flee north was an order issued by British General Lord Cornwallis in August 1780. He boldly

Catawba Patriots Flee to Virginia

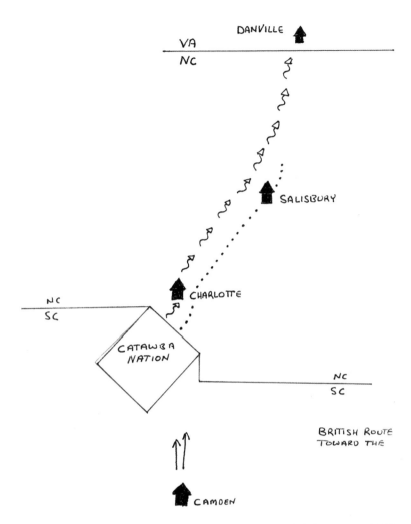

During the final stages of the American Revolution, the Catawba men packed their women and children onto wagons and fled to an unknown location between Danville, Virginia, and what eventually came to be known as Roanoke. This map shows the route north that the Catawba took. At this time, we cannot follow their route north of Salisbury, North Carolina, but the major road went from that town to Danville. On their return home, we pick up their trail again at Salisbury. *Illustration by the author.*

threatened to punish the rebellious Americans with "great vigor" and to "destroy their property." American militia members of questionable loyalty faced execution in this order. The Catawba had understood the intentions of the British at their barbaric worst at the massacre at the Waxhaws. The Indians refused to leave their families at risk.

In August of 1780, the Catawba loaded what they could of their property into wagons and onto packhorses and abandoned their towns to the British. They

followed the American forces on the road from the Nation to Charlotte and from hence to Salisbury, North Carolina, and from that town to an unknown destination in Virginia. Their final hiding place remains up to conjecture. Scant records tell us the Catawba merely found refuge in Virginia. Fortunately for the Catawba, that part of Virginia to which they fled was yet unsettled and almost any mountain would have provided them with a hiding place for their women and children. Since the Catawba had long traveled this road as they made their way to the Iroquois in their ancient war of vengeance, the men knew these mountains very well. In addition, the land around modern Danville was still occupied by Catawban speakers and was once claimed by Cofitachique when the Catawba realm consisted of 55,000 square miles through the Carolinas to mountains of southern Virginia. Today we know the Indians who inhabit this area as the Monacans.

In spite of the old road's direction and the facts listed above, some scholars suggest the Catawba fled to the Pamunkey tribe in the Tidewater area of Virginia. Such a destination was not logical. The Pamunkey were an alien Algonquian-speaking tribe and they lived in the flat tidal lands of the east. The original supposition was based on the fact that after the war some of the Pamunkey men moved to the Catawba Nation to marry Catawba women. There is an additional problem in that the Pamunkey lived close to the Virginia war front, just a few miles west of Yorktown, the place of the final British effort and surrender. The Catawba were too war-wise to leave their families close to an area they did not know and so close to the British lines. Why take their women and children from one danger zone and place them in another? The mountains provided safe haven during this period of turmoil.

I propose that the Catawba simply followed the Americans as they fled north as far as the Virginia state line, near modern Danville or north of that place, perhaps as far north as the Roanoke area. In any case the Catawba women and children were far from harm, perhaps in some unsettled hamlet such as the modern Catawba, Virginia, which is only five miles to the west of Roanoke and hidden behind a mountain. In any case Roanoke had yet to be settled and thus far had not been named. The hiding place possibilities, however, were endless and the Catawba men knew them all.

When the Catawba men returned home under the command of American General Greene in 1781, some nine months later, they followed the same ancient route south through Salisbury, North Carolina. Their progress from Charlotte, North Carolina, to the Nation was recorded by David Hutchinson:

> *When General Greene turned south, the Indians brought their women and children from Virginia, and dispatched some of their number to bring word as to the situation of the property which they had left. They received word from Charlotte,*

Catawba Patriots Flee to Virginia

about thirty miles from their towns, that all was gone: cattle, hogs, fowl, etc., all gone. They came five miles further, and encamped upon the plantation on which I then lived.

The Catawba men, once their families were situated at home, returned to serve the American cause until the British surrendered at Yorktown, Virginia. We know little of the Catawba struggle to rebuild what they had lost. The United States did, however, provide some financial help so the Indians could replace livestock stolen by the British and their sympathizers.

Originally published as "Tribe Moves to Virginia," *The Herald*, July 29, 1999.

Rhoda Harris
A Child of a Seminole War

In the first half of the nineteenth century, the United States was troubled by renegade attacks originating in Florida. The colony had become a haven for rebellious Seminole, lawless whites and runaway slaves. These people living outside the law periodically entered Georgia to raid unprotected homesteads. Three costly wars were fought to end these pillaging expeditions. Between 1817 and 1858, thousands of settlers and more than 1,200 soldiers lost their lives in Florida.

The Seminole Wars are important to Catawba history. Each time war broke out the United States called for troops. Naturally those states closest to the war action were most generous in providing militia. South Carolina, because of its runaway slave problem, was fast to send troops to Georgia and north Florida. These Carolinians included Indian volunteers. The Catawba were among the forces sent to fight the Seminoles, but to date no roster of troops has been found that contains Catawba names. Extensive searches were made by the South Carolina Department of Archives and History and the National Archives in Washington, D.C. All came back negative. It soon became obvious that the effort to link the Catawba to the Seminole Wars had to take another direction.

Catawba folk history has something to say about the Seminole Wars. The Catawba were always eager to serve in the military and willingly went off to any war front. At the end of the First Seminole campaign, while journeying home toward South Carolina through Georgia, they saw a column of smoke on the road ahead. As they approached the fire, they discovered a massacre had occurred just hours before. The house and its outbuilding still smoldered. Its inhabitants lay dead in the yard. The scene was not an unusual one for those who saw action in the Seminole Wars. Too late to help the settlers they had come to help protect, the Catawba men took sticks and began to rummage through the hot ashes. They sought any valuable that might have survived the fire. As they methodically probed in the ruins, they heard what they thought was the sound of a whining dog.

The whimpering came from a rain barrel that stood untouched in the yard. To the Indians' surprise, the Catawba found a little girl huddled inside. It is not hard for us to imagine the scene during the attack. The girl's mother had tossed her child

Rhoda Harris, A Child of a Seminole War

Rhoda George Harris with her granddaughter, Rosie Harris Wheelock. *Courtesy of the Thomas J. Blumer Collection.*

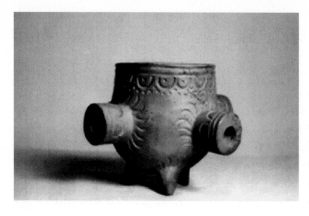

A peace pipe taken from a set of molds made by Rhoda Harris. This pipe shows traditional Catawba incising and was made by either Rhoda or one of her family members in the nineteenth century. *Courtesy of the Thomas J. Blumer Collection.*

in the barrel for safety. The settlers could not defend their home with a toddler getting in the way.

As the surprised Indians picked the child out of the barrel, she declared, "Me Whoda." The Catawba tried to find some member of little Rhoda's family among the surrounding settlers, but their efforts failed. So, "Me Whoda" was adopted by the Catawba and taken back to their reservation in South Carolina.

Rhoda Harris always understood that she was a foundling and a war victim. Her given name, Rhoda, was all she saved from her massacred family and the smoldering ruins of her parents' homestead. The compassionate Indians carried her home to the Catawba Nation. There she was nurtured and protected. It is thought that she became a member of the Catawba George family. She quickly forgot the few English words her mother had taught her. Rhoda's first language became Catawba.

Rhoda Harris never learned to read or write. She spoke only Catawba until the day she died, and her children were among the last speakers of the dying language. In the 1840s, she married Allen Harris, who later became chief of the Catawba. She had six children. In 1860, while Chief Harris was inspecting land in Indian country with the removal of the Catawba in mind, ex-Governor of South Carolina Robert Allston cited Rhoda and four other Catawba women as "model mothers." Little is known of Allen and Rhoda Harris's friendship with Governor Allston, but when their last child and only son was born in 1857, he was named Allston Harris after the governor.

Rhoda Harris was a woman of many contributions. She was a talented master potter and highly skilled maker of pipe molds. According to family history, she made her molds in the 1880s before she went permanently blind. These molds are still treasured by Rhoda's descendants of the sixth generation. These historically important molds are still frequently used to make the smoking pipes for which the Catawba are so famous.

Although Rhoda's reputation as a Catawba of importance was well established and although the events surrounding her foundling status are undisputed, there

remains nonetheless the mystery of which Seminole War led to her rescue and adoption by the Catawba.

When Rhoda Harris died on March 16, 1919, her obituary claimed she was more than one hundred years old. If this is the case, Rhoda was a victim of the First Seminole War (1817–18). However, by her own account in the federal censuses taken between 1880 and 1910, she claimed she was born some time between 1828 and 1830, making her a victim of the Second Seminole War (1835–42).

It makes little difference which Seminole War served as Rhoda Harris's introduction to the Catawba Nation. She was welcomed into the Catawba tribe in an act of generosity, and she generously spent nearly a century serving her newfound family.

Originally published as "'Me Whoda': A Child of the Seminole Wars," *The Herald*, July 1, 1999.

Treaty of Nations Ford 1840

The Treaty of Nations Ford, also known as the Treaty of 1840, got good press in York County for over 150 years. This is odd since the Catawba tribe consisted of barely fifty people in 1840 and remains a small community to this day. For a time, the tribe remained so small that South Carolina looked forward to the extinction of the Catawba, but this did not happen. So the negotiations to settle the generous treaty articles agreed to by the Indians dragged on. By the 1970s, South Carolina's inaction had become a legal nightmare.

The treaty was the product of long discussion in Columbia and much evasion on the part of the Indians. Almost immediately after the 144,000-acre reservation was agreed upon in the Treaty of Augusta (1763), land-hungry white farmers began moving onto Catawba lands. The first settlers were happy to be on Indian land. As time progressed and property values grew, the settlers (by then Indian leaseholders) became dissatisfied with their rents, often as low as ten cents per year. To make matters worse, they were not represented in the South Carolina legislature. The problem remained as long as the landowning Catawba survived. A solution had to be found, and the leaseholders frequently petitioned Columbia asking for a settlement.

The final decision to settle the Catawba matter was made around 1830. Two years later, the legislature was ready to pass a bill to end Catawba ownership and accomplish the last Indian land grab that South Carolina would see. One problem remained: the Catawba had to agree. This was not easy. The Indians were willing to talk, but they never seemed ready to discuss the matter with any seriousness. From the Catawba perspective, the problem rested in a deep-seated conservatism found in the Catawba ruling class.

Catawba King Frow abdicated in 1776, and the Catawba created a republic, at least on the surface. The new ruler was called a "general," but he was chosen by ancient succession rules that followed the female line. Today, these rules are barely understood, but the Catawba in the early nineteenth century understood them well and followed them. The Catawba rulers, all of the royal line from General NewRiver in 1776 to General William Harris in 1838, were conservative. They insisted that King Haigler's legacy remain intact. At one point, the negotiating

commission correctly decided that South Carolina would have to wait for the old guard to die off.

While South Carolina waited for luck to turn, the negotiations failed regularly. Commissions were sent to study the matter in 1833, 1835 and 1836. At one point, commissioners were paid $22.20 a day. Responsible citizens in Columbia and the York District knew the Indians depended on the leasing for their support. In the end, such men did not prevail and the Catawba were left without a means to feed themselves.

The last Catawba ruler to resist parting with the Catawba Nation's patrimony and major source of income was General William Harris. He began his rule in 1838 and died in 1839. His successor was just what the leaseholders and the South Carolina Legislature had sought for so long. This new general's wife was descended from King Haigler, but General Kegg was not a traditionalist Catawba. He was half Pamunkey and not at all impassioned over preserving the Catawba reservation and hence the tribe's income. He thought a move to join the Cherokee in the mountains of North Carolina might be a good idea. He also sullied his place in Catawba history when he sought to obtain for his own use the little money that South Carolina had approved for the treaty.

The Treaty of Nations Ford is a simple document. Article one conveyed the 144,000-acre reservation to South Carolina. This article was, of course, carried out with the full acquiescence of the Catawba. Article two provided the Catawba with a new tract of land far removed from white settlements. Article two, caught in a political vacuum between North and South Carolina, was never fulfilled. Article three regarded payment for the 144,000-acre reservation. South Carolina never made proper payments and the debt remains unsettled.

The signing ceremony was interesting. Local history does little concerning this fateful day except to restate the names of the signatories. Catawba tradition, however, tells us something of South Carolina's fears. When the parties met at Nations Ford, a barrel of whiskey had been placed there by leaseholders. Drinking cups hung around the rim. The intention was to toast the historic event. If the Indians changed their minds, the whiskey was ready to make them more agreeable.

The Treaty of Nations Ford was an immediate disaster for the Catawba Nation. Those Catawba who were living among the Cherokee hurried home to tend their farms. The remaining Catawba gathered around David Harris, a descendant of Revolutionary War hero Peter Harris. These people began their march west to join the Cherokee. They soon lost their zeal for removal and barely left York District. They returned to their ancestral lands, which no longer belonged to them. The Catawba plight became an embarrassment to right-thinking citizens in the area. The long saga that ended with the Settlement of 1993 had begun.

Originally published as "Negotiations Drag On for Over 150 Years," *The Herald*, April 17, 2000.

Removal Attempt of 1860

A key factor in the Catawba Nation Settlement of 1993 was that South Carolina never saw to the ratification of the Treaty of Nations Ford (1840) by the United States Senate. The issues around the treaty, however, were not dead. Those people most concerned with the injustice—the Catawba themselves—worked relentlessly to see the treaty's articles honored in spite of the illegality of the treaty itself. The Indians' efforts were hampered by a lack of resources: money and education. Progress was still made slowly, Indian style, from one decade to the next. As a result, a fantastically rich legal paper trail was left for the Native American Rights Fund (NARF) when the case was taken to court in the late 1970s.

The Catawba were never satisfied with the 640-acre reservation purchased for the tribe with state funds as a temporary home until a new and acceptable tract of land was found in conformity with article four of the treaty: "To furnish the Catawba with a tract of land…where the Indians might desire." The term "desire" was a problem. Several attempts were made between 1840 and 1860 to find such a tract. All ended in failure. The removal attempt of 1859–60, the last of such efforts, is of particular interest.

The actual impetus for the removal attempt of 1859 was part of an on-again, off-again interest on the part of South Carolina to be rid of the Catawba. It was also a response to the Indians' constant request that the land article of the Treaty of Nations Ford be honored. In the fall of 1858, a special legislative committee reported that the Catawba were ready to move. There was, however, a glitch. Half of the Indians wanted to inspect the land first. This demand was in accordance with the treaty. The Catawba could not be removed without their consent. At the same time, the South Carolina legislature, a legal entity of the second richest state in the Union, was bemoaning the loss of $5,000 that the United States Congress had appropriated for Catawba removal in 1855. This unspent sum of money had been returned to Congress. Now South Carolina had to foot the removal bill alone. The offer was still good that the Choctaw had plenty of land and were willing to allow the Catawba to settle in their Nation in Indian country.

Removal Attempt of 1860

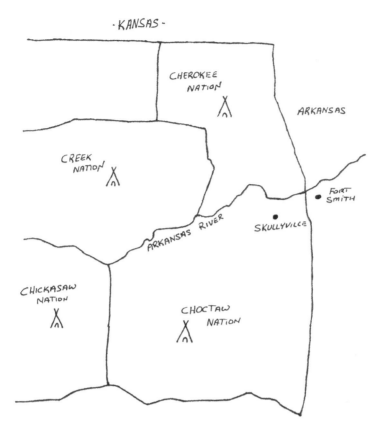

· KANSAS ·

CHEROKEE NATION

ARKANSAS

CREEK NATION

FORT SMITH

ARKANSAS RIVER

SKULLYVILLE

CHICKASAW NATION

CHOCTAW NATION

Skullyville was the probable arrival place of the Catawba delegation and the possible burial place for Chief Allen Harris. It was the arrival depot for all Indians coming into Indian territory. By the time the Catawba delegation arrived, Skullyville was the fist stagecoach stop coming out of Fort Smith, Arkansas, on the Butterfield Overland Mail Route. After the railroad came through this part of the Choctaw Nation in 1917, Skullyville became a ghost town. *Illustration by the author.*

Another factor in this removal effort was a unique Catawba/Choctaw relationship. In 1851, four Catawba families joined the Choctaw and had been granted Choctaw citizenship. As a result, a number of Catawba were already living in the Choctaw Nation. These individuals were from the Ayers, Heart, Kegg and Morrison families. Their presence and their satisfaction with life among the Choctaw played a role in the events of 1859.

In a rare example of action, in December of 1859, the South Carolina legislature appropriated $500 to pay Special Agent David G. Rice to handle the land inspection in Indian territory and coax the Catawba into moving west. It was agreed that two or three Catawba were to accompany Rice to the Choctaw Nation. The delegation finally consisted of Chief Allen Harris, Councilman John Harris and Rice. The three men left for Indian territory on July 16, 1860. Unfortunately

for the project, Chief Harris died soon after arrival in the Choctaw Nation. With a key player in these events gone, problems loomed on the horizon. However, John Harris remained with agent Rice and gave the project new life. He wrote a glowing letter home regarding the warm reception they had received from the Choctaw and described the fine farm land available to the Catawba should they move. A majority of the Catawba General Council was ready to leave South Carolina for Indian territory. South Carolina was about to solve an ancient legal problem. If the Catawba were to move, the illegality of the Treaty of Nations Ford would become a moot point.

After his return home, Agent Rice presented his report to the South Carolina legislature on November 28, 1860. He provided a detailed account of how he had spent $1,112.78 on his and the Catawbas' needs. He also spoke highly of the removal project.

> *The head man Allen Harris died soon after reaching there and the other* [John Harris] *was well pleased with the country so much so that he induced a majority of the tribe here to petition the Choctaw Council for admission but for some miscarriage we heard nothing from the said Council* [Choctaw]. *I think it would lend greatly to the happiness and prosperity of the Catawbas to emigrate to said Country. The whole authority is vested in the Choctaw Council and as we have not heard from them I would recommend to defer action for the present.*

Agent Rice was wrong to place the blame before the Choctaw General Council. They had approved the Catawba removal in November of 1856. The real problem was that by November 1860, South Carolina was deep in the Secession debate. Less than a month later, December 20, 1860, Secession was a reality. No one in the legislature was interested in Catawba removal. The episode in Catawba history was preparation for war. The Catawba stood ready to serve the Confederacy and the Choctaw in Indian country did the same.

Originally published as "1860 Removal of Indians Had Lasting Effects," *The Herald*, September 23, 1999; and "Chief Allen Harris and the Would-be Catawba Removal of 1860," *The Quarterly* 1, York County, South Carolina, June 1993.

War Between the States

When South Carolina seceded from the Union and war broke out in 1861, the Catawba Nation's total population consisted of between eighty to one hundred men, women and children. The tribe was relatively prosperous, according to accounts made just before the war. In fact, a tribal member by the name of Betsy Scott was conducting a Catawba Indian School on the reservation. The Catawba General Council had just considered removing to Indian territory to incorporate with the Choctaw Nation. Even though this project collapsed when South Carolina seceded from the Union on December 20, 1860, there was an air of hope among the Indians. The Catawba soon learned, however, that there was no turning back from the prospect of war when Fort Sumter was bombarded by Confederate artillery on April 12, 1861. Fort Sumter was surrendered to the Confederacy by Union troops two days later.

The Catawba responded just as they had always done: all the tribe's able-bodied men joined the Confederate States army.

In the years following this war, there was an ugly rumor that the Catawba men were forced into enlisting in the army. This, according to the Catawba Confederate records, was just not true. There was, however, no whole-scale Catawba enlistment. The men joined in family groups at odd times. They served in a number of units. By the end of the war, one man, William Canty, had two enlistments to his credit. No one forced him to join. In all, seventeen Catawba saw action, mostly on the battlefields of Virginia, Maryland and Pennsylvania.

Since a large number of Confederate military records were destroyed in the last days before the surrender at Appomattox, we will never know the full scope of Catawba contributions to the Confederate States army. The Indians fought to keep South Carolina free and most of the Indians either sacrificed their lives or their ability to work during the war.

So poor are the surviving Confederate records that there is some confusion regarding a full Catawba roster. The Confederate Monument provides a list of veterans but it seems to be incorrect in several of the names listed there. Some who perhaps did not serve are listed on the monument and others who did serve were omitted.

This portrait of Robert Head is the only photograph of a Catawba Confederate soldier in uniform to survive, as far as we know. The original is a daguerreotype. *Courtesy of Wayne Head, descendant of Robert Head.*

War Between the States

The first Catawba men to enlist joined Company K of the South Carolina Seventeenth Infantry on December 9, 1861. Those who joined at this time included Jefferson Ayers, William Canty, John Scott and Alexander Tims. Eleven days later, on December 20, 1861, two brothers, James and John Harris, joined Company H of the Twelfth South Carolina Infantry. The third early enlistment occurred on May 13, 1862, and included Robert Crawford, Robert Head and Peter Harris. These men joined Company G of the Fifth South Carolina Infantry.

We do not have room to enumerate all the battles these men experienced. The list reads like a complete chronology of the actions fought on the Virginia front. Jefferson Ayers was the first casualty. He was wounded in 1862 and died as a prisoner of war at Point Lookout, Maryland. William Canty and John Scott were among the few who made it home unhurt. Alexander Tims was wounded at the First Battle of Manassas but stayed in the trenches until the war's end.

James Harris was wounded at the Battle of Antietam in 1862 but served his company right up to the surrender at Appomattox, Virginia. His brother, John Harris, who had visited the Choctaw Nation to inspect land offered to the Catawba with removal in mind in 1860, was wounded and captured by the enemy. Later, John Harris was listed as a member of the Invalid Corps. Robert Crawford, the second casualty, was lost in battle and assumed dead. He never returned home to the Catawba Nation to his wife and his infant daughter Betsy Crawford. Robert Head died of battlefield wounds. Peter Harris became a prisoner of war and was imprisoned at Hart's Island in New York Harbor.

Peter Harris's bravery was saluted by the *Fort Mill Times:*

> *At the Battle of Sharpsburg* [Antietam] *he was severely wounded through the knee and fell to the ground unable to walk. Realizing the danger from the enemy's fire to which his position subjected him, Peter crawled backward 50 yards to a place of safety, supporting his injured leg by resting it upon the other one. After the wound healed, Peter returned to his company and continued to the end of the war to fight for the Confederacy.*

The Catawba men served the Confederacy with great honor in the first half of the war. Of the nine who enlisted during the early years, three died. As far as we know, only two of the nine returned home without permanent disabilities.

On the homefront, the Catawba women and children made and peddled pottery in an impoverished local market, tended their gardens and waited for their men to return home triumphant.

Originally published as "Catawbas Had Presence in Civil War," *The Herald,* November 18, 1999.

The War Ends

As the War Between the States dragged on, the situation on the Catawba Reservation became ever more critical. The number of wounded and those lost or killed in action grew way out of proportion to the small size of the Catawba Nation population. Statistically, the Catawba lost more men than any other South Carolina community. Throughout the period, the Indian women continued to raise their children, tend their gardens and peddle pottery by foot.

Although money was scarce in South Carolina, this made little difference to the potters. The Indians had long traded for goods rather than money. The system the Catawba used was frozen in dim prehistory. It was followed by the potters right into the mid-twentieth century. If the buyer did not have cash, the Indians accepted food or clothing. Traditionally the measure for wheat flour was the contents of the pottery vessel being sold. The measure for cornmeal was double the contents of the pot. In spite of heroic efforts on the part of the women, on occasion the Catawba faced starvation conditions.

Dismal news kept coming from the war front. In spite of this fact, the men continued to enlist in the Confederate States army and leave for Virginia's battlefields.

Robert Mush was one of the last Catawba men to join the glorious cause. He went alone, probably because he identified more as a Pamunkey than a Catawba. On April 4, 1863, he joined Company K of the Seventeenth South Carolina Infantry. He died of battlefield-related illness at home on August 4, 1864. Next to enlist was William Canty, who joined for a second enlistment on July 7, 1864. He was accompanied by Nelson George. They both joined Company H of the Twelfth South Carolina Infantry. William Canty never came home. According to Catawba tradition, he died in battle. Nelson George was taken prisoner at the Battle of Reams Station, Virginia, and spent the duration of the war in a prisoner of war camp. He was paroled on May 16, 1865, in Charlotte, North Carolina.

An additional number of Catawba served in the Confederate States army, but no records have survived. For them we must rely on Catawba tradition only. For

instance, no official records exist for Franklin Canty. John Brown's records have been lost too, but his tombstone in the Old Catawba Cemetery records his veteran status. John Brown lost his leg in battle and died in Charleston, South Carolina, of a fever in September 1867. Gilbert George survived the war to return home, but he disappears from Catawba history in 1869. John Sanders also died in battle, but no records have been located. William Sanders is recorded by Catawba tradition as a Confederate States army veteran, but left no record. The youngest Confederate soldier was James Patterson, who lied about his age and enlisted in the army at twelve. He served for a short time, according to his testimony.

The following statement appeared in the Rock Hill *Herald* on December 10, 1965. Though the reporter was only talking about James and John Harris, this tribute could be applied to all those Catawba men who jumped to the defense of South Carolina in her great hour of need.

> *Their conduct throughout that bloody conflict was marked with great courage and fidelity. They both entered the service as cooks, but afterwards participated in the active service. They were wounded several times, but survived the conflict, and died since at their homes in the Catawba Nation, where their bodies were interred.*
>
> *John was a cripple through life from a wound received at the Battle of Sharpsburg. While engaged in the fight there he was shot through one of his legs and it appearing that he might fall into the hands of the enemy, begged his comrades to kill him rather than permit this to happen. They were both good soldiers under all circumstances and it is suggested that Company H take steps to preserve the memory of their gallantry and fidelity in some suitable way.*

Today the Catawba men who served the Confederacy are memorialized on the Catawba Confederate Monument in Fort Mill. The list etched in stone is incorrect and incomplete; we can say, however, that the Fort Mill monument correctly reflects the condition of the Confederate service records. We also know that the Catawba have never shirked their duty to support the military and many paid the ultimate price for their loyalty to South Carolina, their ancient home.

Originally published as "Locals Filled CSA Ranks," *The Herald*, December 12, 1999.

Reconstruction
1865-1877

The Catawba loyally saw the end of the War Between the States and began the Reconstruction era with little hope. As a prelude to this period, a bad omen was the Sherman's Flood of the Catawba River in January 1865. The Indians lost their crops. The Catawba families made pottery to make up for the loss, but few other resources were available.

The next axe to fall was the removal of state-employed Indian Agent John Patton, whose job was to represent the tribe in court and dole out state money appropriated for support of the Catawba. Patton was, however, replaced by a friend and longtime resident of the county, Thomas Whitesides. The few able-bodied men who had survived the war cut cordwood, and the tribe's members waited for their share of the appropriation to supplement their subsistence income. Unfortunately, 1866 brought a major drought. Again the crops planted in the Catawba River bottoms were lost. In April 1867, Whitesides obtained some corn, which he distributed to the fifty-plus hungry Indians.

South Carolina, however, remained in confusion. Before long, Whitesides wrote Columbia for instructions. His message was one of alarm: "Some families of the Indians are at this time in a very destitute condition, and it is not in my power to assist them." The agent did not know how to approach the new bureaucracy in Columbia and draw on the Catawba appropriation. The answer was that $1,200 had been set aside for distribution to the Catawba, and Whitesides merely had to provide vouchers.

The year 1868 was no better. The Catawba continued to endure starvation conditions. Grain was not available in York or Lancaster Counties. Whitesides finally succeeded in purchasing corn in Charlotte, North Carolina. The grain was brought in by train and taken to a bridge on the Catawba River. At this arranged site—the White Grist Mill at Nation's Ford Crossing—Whitesides was "met by the Indians, and, a mill being in that vicinity, the corn was at once distributed to the Indians without taking receipts."

The result was an investigation into the agent's honesty. Columbia charged that merchants who were commissioned to give the Indians food had provided them

with whiskey and tobacco instead. Whitesides defended the merchants as reputable. In response, Provisional Governor James L. Orr sent a mere half of the Catawba appropriation, money that the Catawba desperately needed.

Outraged, Agent Whitesides fired off a letter to Governor Orr. Catawba Chief John Scott was present when the food was distributed, and he defended Whitesides. The situation continued to deteriorate. In February of that year, Judge Beatty wrote, "I am informed by Mr. Whitesides that many of the Indians are in so destitute and almost starving condition and that it is important that the small pittance allowed them should be drawn at once." The answer from Columbia: "Wait seven months."

In July the Catawba petitioned Governor Orr for relief. They asked that a John Morrow replace Whitesides. The petition was signed by eleven tribal leaders. A total of $850.40 was distributed in two installments.

P.J. O'Connell was named agent in 1870, but the Catawba account continued to reflect the situation in Columbia. The response was yet another Catawba petition and a second petition from concerned white citizens. This second petition from the community at large asked that a new Catawba agent be appointed. O'Connell resigned in December 1872.

The situation on the Catawba reservation continued to deteriorate under scalawag Governor Robert K. Scott (1872–1874). This man who had accompanied Sherman in his March to the Sea did nothing to help South Carolina or the Catawba. He, in fact, tripled South Carolina's debt. The Catawba petitioned Columbia for a solution to their problem in 1873 and asked that R.L. Crook be named as their agent. In 1873, under Governor Scott, only $40 was distributed. The desperate Indians requested that William Whyte be appointed to the position of Indian agent. In 1875, Columbia was ruled by a carpetbagger, Daniel H. Chamberlain, who hailed from Massachusetts. Chamberlain admitted that $2,145 was owed to the Catawba. This admission did little to solve the problem of distribution. Chamberlain eventually left South Carolina for New York, where he practiced law.

This sad chapter in the history of the Catawba Nation ended with the election of Governor Wade Hampton III. The situation on the Catawba Reservation improved immediately. Whyte was appointed Indian agent, and the Catawba appropriation money flowed on schedule for the first time since the end of the War Between the States. The scandals of Reconstruction ended.

The Catawba had suffered much since Secession, but the children of the war years were now adults and able to contribute to the Catawba Nation's economic survival. The men cut cordwood and did other day labor. They also made smoking pipes in their unemployed hours. Families once again loaded wagons with pottery and peddled their wares across the countryside. The Indians had survived two tragedies that followed in quick succession, but they faced the 1880s with new hope.

Originally published as "Catawbas Struggle in Reconstruction," *The Herald*, June 3, 1999.

The Murder of Austin (Allison) Harris, 1881

My introduction to the murder of Austin Harris came as a surprise soon after I began a series of tapes with his great-granddaughter, Doris Wheelock Blue. She told me that he was "in a place he should not have been in" and he was killed by three white men who went unpunished. I went down to the cemetery on the old reservation and got his date of death and went to the newspapers and found extensive coverage. This article is the result of reading those accounts from the *Yorkville Enquirer*. The murder of Austin Harris created a sensation in York County.

It is impossible to measure the sorrow felt by the Catawba upon the murder of a young Indian twenty-two years of age. He was the son of Chief Allen Harris and Rhoda Harris. Both of his parents were of great cultural and historical importance to the tribe, and people looked for him to do great things with his life. Since the birth of Austin Harris nearly coincided with the death of his father in 1859, we are not sure if Chief Harris ever had the pleasure of holding his son in his arms. Rhoda raised him alone and still managed to leave a mark on the Catawba Nation through her pottery.

The story of those who stabbed Austin to death is likewise pathetic, yet they lived to suffer from their heinous deed, if they ever gave it a second thought. James Duffy was eighteen years old and from Fort Mill. He already had a reputation for violent behavior. He purchased the knife used in the crime three days earlier in Rock Hill. It cost him one dollar. Hampton Owens, the second assailant, held Austin Harris while Duffy stabbed him. Owens was twenty-two years old. We do not know the age of the third man involved in Austin's death. He must have been around the same age as the other two men. John Pardue helped Owens to hold Austin while he was stabbed repeatedly by Duffy.

Two Indians were there with Austin: James Harris, later Chief Harris, and Wesley Harris.

The crime took place in the Blackjacks section of York County at a house of ill repute run by a white woman named Mag Hines. The place was two miles south of Rock Hill and about seven or eight miles west of the Catawba Nation on Cowan Road. The home of Mag Hines was referred to as a "place of resort"

The Murder of Austin (Allison) Harris, 1881

for young men. Alcohol flowed freely there; it was a place of much laughter and violence. Those who had to discuss the place in court were embarrassed to talk of it.

None of the three white men was drunk. Of the Indians, James Harris admitted to having had something to drink. Wesley Harris was reported to have been very drunk.

When the Indians left the Nation just before dark, they planned an evening of fun. Austin took his fiddle along to entertain the folks. James Harris rode a lame mule. Two of the white men, Duffy and Owens, left Rock Hill around the same time in a buggy. Other white men who took part or witnessed the crime, including Pardue, left Rock Hill around dusk. They all gathered at the home of Sallie Hines. The night was marked by Austin's fiddle music, drinking and laughter.

Apparently the fracas was begun by Wesley Harris, who emerged from Mag Hines's house cursing. Duffy took the remarks personally. The two men fought in the yard while Austin played his fiddle inside the house. We know little of how the events progressed, but Austin Harris broke his fiddle over Duffy's head. Owens hit one of the Indians with a broken chair. This apparently turned into a classic barroom brawl. The fight broke up and the Indians started for the Nation.

James Duffy and Hampton Owens heard the Indians, who were down the road. Challenges were uttered. Austin Harris gave his coat to James Harris, who went on home. Austin's knife was in its pocket and therefore Austin was left without a weapon. The fight was between four men: Austin, Duffy, Owens and Pardue. Pardue and Owens held Austin while Duffy cut him. In the process, Duffy cut Pardue and Duffy's coat was damaged. Eventually Duffy and Owens left Austin Harris lying in the road, bleeding. Owens said, "Jim has cut the Indian and I believe he is going to die." The time was 10:00 p.m. and the men left Austin to die alone in the road.

By midnight, Duffy and Owens returned to the scene of the crime with Dr. Crawford of Rock Hill. While in Rock Hill, Duffy was reported as having said, "I cut the Indian and that if ever two men jumped on him again, he would do the same thing."

Duffy, Owens and Pardue were arrested around 1:00 or 2:00 a.m. the next day.

Austin was left to lie on the ground all night. He was found by Sampson Owl, a Cherokee, and Bill Harris, a Catawba.

James Duffy and Hampton Owens spent a total of a month in jail. The trial was held from March 31, 1881, to April 2, 1881. Judge T.B. Fraser lectured the jury to keep race out of the matter and talked of the nature of homicide. The jury was out for two hours and twenty minutes and returned a verdict of "not guilty."

It is true that all the men involved were in a bad place and all were prone to violence, but Austin Harris was attacked and killed not by one man but by three. Austin was unarmed.

Catawba Nation

An effort was made by the local paper, the *Evening Herald*, to whitewash the events and present the white men as innocent. The paper wrongly said that the Indians pursued Duffy, Owns and Pardue. The paper also reported that Duffy had acted in self-defense. Yet a helpless human being was left in the road to die.

Nancy Whitesides, a Catawba, was left pregnant with Austin's baby. The girl, Rosie Harris, was given to Rhoda and her daughter, Betsy Harris, to raise. Rosie grew up without knowing her father. Her mother eventually moved to Jacksonville, Florida. Rosie was sent to Carlisle Indian Industrial, where she met an Oneida of great promise, Archie Wheelock. Rosie eventually told her two girls, Doris and Edna, that their grandfather had "been killed by three white men in a place where he should not have been."

We have no idea what happened to James Duffy, Hampton Owens and John Pardue. It is thought that they continued their lives marked by violence.

Originally published in *The Herald*, June 10, 1999.

Chief James Harris
1858-1912

The Catawba have survived as a nation for many reasons. Fortunately, they had leaders of great genius at critical points in their history. One of these men was Chief James Harris. Local non-Indians complimented him on many occasions, calling him the smartest Indian ever born on the Catawba Reservation.

King Haigler set the stage for the Catawba Nation's political survival. His contributions of 1760 and 1763 gave the tribe its legal basis for the Catawba Settlement of 1993. The contributions of Chief James Harris overlap those of King Haigler. Harris showed the Catawba that they needed lawyers to handle the ancient land issue. He also pushed the Catawba to accept the benefits of education. These two actions prepared the Catawba for the challenges of the twentieth century.

Chief James Harris, the son of James Harris and Sarah Jane Ayers Harris, was born in 1858. His earliest memories were of the abject poverty the tribe suffered during the War Between the States and Reconstruction. Like the other Indian men, he cut cordwood at fifty cents a cord and farmed the often-flooded Catawba River bottoms on the reservation. He first married Fannie Harris around 1879. She died without bearing him any children. His second marriage was to Margaret Harris. With Margaret he began a family dominated by Georgia Harris, who gained recognition in the twentieth century as a master potter.

James Harris's political life began when Tom Morrison returned from the Choctaw Nation in Indian country and was subsequently elected chief of the Catawba. Morrison was deaf and needed the support of an intelligent young man; he wisely chose James Harris to assist him in bringing the old land claim back to life.

In 1885, Chief Morrison and James Harris visited Washington, D.C., to investigate the tribe's claim to the 144,000 acres reserved by the Treaty of Augusta in 1763. The two men bravely forged ahead using the few financial resources available to them. In 1887, they hired Attorney J.Q. Marshall of nearby Lancaster, South Carolina. He was the first of a long line of lawyers who handled the claim from 1887 to 1993.

Chief James Harris at the height of his career.
Courtesy of the late Georgia Harris.

This effort, too, floundered for a lack of funds, but James Harris did not give up his quest for justice. When he was elected chief in 1896, he revived the land claim and again employed a Lancaster law firm to continue the investigation. In 1905 he allied himself with an Indian rights' advocate, Seneca Nation President Andrew John. Although none of these efforts worked to see both the United States and South Carolina obey the laws they themselves had drafted, James Harris reminded his people that issues important to them remained unresolved.

Of equal importance was Chief James Harris's interest in obtaining a school for his people. While he was chief, the first Catawba youths attended Carlisle Indian Industrial in Pennsylvania. Chief Harris knew from the beginning that only the brave would leave family and home to gain an education. He also knew those who went to Carlisle first needed the basics. Harris saw a reservation-based school as the solution.

Under his leadership, the Catawba General Council approved a budget for school construction materials. The men cut reservation timber and carried it to a nearby sawmill. Naturally, he was proud of his accomplishment. In 1897, he addressed a letter to H. Lewis Scaife, who in 1896 wrote *The Catawba Indians of South Carolina*, the first general history of the Catawba. It is significant that this booklet was published by the Office of Indian Rights Association in Philadelphia, Pennsylvania. Although Chief James Harris never learned to read and write, he respected these skills because they gave mankind power. It is probable that Harris's letter was dictated to a young Catawba Indian School pupil. In spite of the errors, Harris's pride is easily seen.

Chief James Harris, 1858-1912

One of our tribe, Samuel Blue, loose his wife a few days ago. She has been sick for nearly a year. Our school with open tomorrow, the teacher is Mrs. Eli Dunlap of Lancaster. There will be about 20 pupil will attend. I think you can write Mrs. Dunlap at that place in care of me. I will try to send those Pips [pipes], etc. soon as I can we have none on hand and it will take sometime before I can send them. But nevertheless I will send.

A zealot for justice to the end of his life, Chief James Harris also signed a Catawba petition in 1909. It asked that the Indians be granted United States citizenship. This dream did not come true until the end of World War II. He understood that this basic American right was necessary to Catawba survival.

The year 1912 was a hard one for the family of James and Margaret Harris. They lost two sons, Robert and Thomas, in July of that year. Then on August 31, 1912, James Harris suffered a paralytic stroke. He died two days later on September 2, 1912.

Today James Harris is remembered for his willingness to face the wealth and power of both Washington and Columbia with little financial backing. He knew that once the Catawba found money to litigate, their ancient land claim would be resolved. Chief Harris realized a lack of education was part of the problem. The two—money and education—came together in 1979. Even with these aids to progress the struggle was a long one for the Catawba. The settlement Chief James Harris sought was at last realized in 1993.

Originally published as "Catawba Chief James Harris Was a Leader with Zeal," *The Herald*, June 10, 1999.

Catawba Indian School

The Catawba's interest in educating their children has a long and complicated history. The Catawba sent young boys as hostages to the school at Fort Christanna in the early eighteenth century. Later, just before the American Revolution, John Nettles attended the Indian School at the College of William and Mary in Williamsburg, Virginia. Then, at the beginning of the nineteenth century, some Catawba attended the Reverend Rooker's Baptist Mission School. Some Catawba children attended a reservation-based school just before the War Between the States. A few Catawba were fortunate to obtain an education through tutoring provided by neighboring whites. The unschooled Indians were aware that learning to read, write and calculate were goals worthy of attainment.

In the 1870s, Indian country experienced a great push for education. It was felt that education was the key to bringing the American Indian into the mainstream of national life. Carlisle Indian Industrial was founded in Pennsylvania and the Cherokee Boarding School opened its doors in 1881. By 1918 and even earlier, the Catawba were sending some children to this Cherokee Boarding School. The Catawba, aware of these advancements, dreamed of building their own school. Chief James Harris, a visionary of King Haigler's ilk, changed Catawba history and brought permanent educational opportunities to the reservation.

According to the Indian agent's 1896 report, the tribe had set aside funds for both building of a school and paying a teacher. In December 1896, a Presbyterian committee met in Rock Hill and hired Bessie Dunlap of Lancaster to teach in the Catawba Indian School. The tribe's General Council had already earmarked $133 of tribal money for the project. The Indians provided labor, and the finished building was sixteen by twenty-four feet. Though it was a small, one-room schoolhouse, it was a start.

The Catawba Indian School opened on February 4, 1897, with twenty pupils. Ben Harris, a man who had obtained his education through the generous tutoring of a local teacher, began a night school for adults. Mrs. Bessie Dunlap purchased

Catawba Indian School

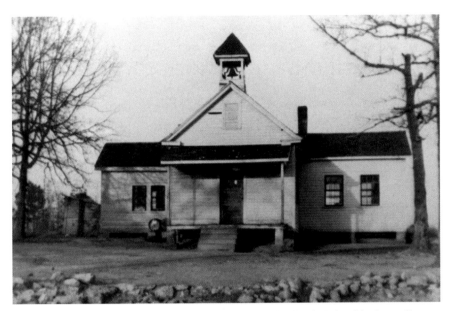

As built by the Catawba under the direction of Chief James Harris, the Catawba Indian School originally consisted of the central part of the building. When the growing Catawba population provided more children than the school could hold, the Catawba built the two side wings, which provided the nation with adequate schoolrooms until the 1940s. *Courtesy of the Thomas J. Blumer Collection.*

a secondhand organ for twenty dollars and boasted two music pupils: Ben Harris and Robert Lee Harris.

The Catawba Indian School ended its first historic year with formal exercises on May 7, 1897. The festivities included music, recitations, prizes, a fish fry and a barbeque. According to the local newspaper, *The Herald,* "The pupils have been remarkably faithful, diligent and eager to learn." Interest in the school was keen, and Governor Ellerbe of South Carolina visited the reservation in November 1897 to inspect the school.

The South Carolina General Assembly appropriated more money for the school in 1898. A mere $200 provided a school bell, and the single room was finished with a ceiling. The bell soon became an integral part of the reservation communication system. It was used to mark deaths and to call the General Council to meetings. The bell continued to be used in this fashion until the Catawba Indian School was replaced with a larger, more modern building under Chief Raymond Harris following World War II.

Little is known of the first students, except that Bessie Dunlap had better luck luring the girls to classes than she did the boys. We do, however, have a roster for 1899. It reads: "Nora Brown, Lucy George, Maroni George, Nelson Blue, Early Brown, Wade Ayers, Annie Ayers, Sallie Brown, Sallie Harris, Lillie Blue, Edith Harris, Vinia [Lavinia] Harris, Leola Watts, Aritimesa [Artemis] Harris and Arzada Brown."

Catawba Nation

Naturally, the Catawba counted on the teaching talents of tribal members when possible. Ben Harris continued to teach when he was needed. In 1905, Archie Wheelock, an Oneida who had married into the Catawba Nation, taught school. Other Catawba teachers included Kamie Owl Wolfe (Catawba/Cherokee). During the 1913–14 school year, Lula Owl (Catawba/Cherokee) held summer school on the reservation. Rosie Harris Wheelock also taught there for a number of years, and Elsie Blue (George) was a teacher's helper.

Before long, the one-room schoolhouse built by Chief James Harris was too small. In 1914, the state appropriation included $250 for additional rooms. These were added to both sides of the original school and included a second schoolroom and a kitchen. In addition, the Catawba Indian School became the Catawba Nation's cultural center. The students put on plays and Christmas programs. When outsiders visited the reservation, Chief Samuel T. Blue often led the children in Indian singing and dancing. He also tried to foster an interest in the Catawba language.

Although Chief Blue failed in his effort, many of the few Catawba vocabulary words recalled today come from his efforts. In 1930, the school year ended with a play entitled *Nobody's Darling*. Festivities in 1933 were particularly elaborate. Included were two plays: *Fun in a Photographic Gallery* and *Amos and Andy*. Perhaps the highlight of this year's commencement was a "mock wedding." It is not difficult to imagine that this ceremony included the use of the so-called wedding jug. This curious pan-Indian shape originated in the Pueblos of the Southwest and had recently been adopted by the Catawba potters through Cherokee contacts.

By the 1940s the original school no longer met rising enrollment needs. Chief Raymond Harris offered a plan to build a new school. In support, the State of South Carolina appropriated $12,500, and this money was matched by the United States government. The new school was built to house one hundred children. Today this building is the home of the Catawba Cultural Center and the Catawba Nation Archives.

The General Council put the old school up for bid. The building was sturdy, with good floors and a solid roof. It became a comfortable home for Samuel and Helen Beck's family. In July 1954, while the Beck family was at work, the building was struck by lightning and burned to the ground. Samuel and Helen Beck saved nothing from the flames. The Catawba Nation lost a valuable part of their history, but the old Catawba Indian School remains forever etched in the hearts and minds of today's tribal elders.

Originally published as "Catawba Once Attended School on the Reservation," *The Herald*, May 27, 1999.

The Death of
Tom Steven

In mid-January 1905, word reached the Catawba Nation via the Lancaster County Sheriff's Office that an Indian had been found dead along the road near the village of Van Wyck. The Catawba rightly suspected that the message concerned Tom Steven, their oldest tribal member.

Had it not been for this tragic incident, Steven's life might have passed almost unnoticed. He was the last of his family. It is suspected that Tom Steven was related to Chief James Harris's family, but no one knows the connection. Of the several narrations of his last hours, other than that of the James Harris family, the most complete came from Sallie Harris Wade. The following is a composite of two versions: one told to me and the other told to Mrs. Emma Echols.

This version was told by Sallie Harris Wade:

> I remember Grandpa Tom Steven came by our house the day he left the Nation. Most everyone called him "grandpa" cause he was old. We did but we wasn't his grandchildren. He had a grandson or something [James Harris, Sarah Harris's son] that run the ferry right where Bowater is now. So he went down there and stayed all night with them. And his wife was buried in Lancaster somewhere. I used to know where it was, and he went down there and stayed all night. He told us one time his wife's name was Daisy.
>
> But he come by our house that morning and me and Robert [Sallie Wade's brother] followed him to the top of the hill 'cause he always come there, and he'd be back the next day. He was so old. So he went on down there and stayed all night and the next day he left to go to Lancaster where his wife's grave was. It was a cold and rainy day, and they tried to get him not to go. He went anyway, and he went by some man's house over in Lancaster and it was raining. He asked the man [Plyler family] to let him stay all night. The man just slammed the door in his face. They were eating dinner. Grandpa knew the man wouldn't let him stay 'cause he was an Indian. So [Grandpa] went on, and he just below Waxhaw. It rained so. I guess he got cold. He got stuck in the mud and was hanging upon one side of the bank

with hands up like he was trying to climb out of the ditch. With his hands up like that he froze to the bank.

The sheriff of Lancaster County was riding around looking and found him, and he called us over here and told them. Told there was some one of the Indians over there dead and was in the road froze to death. We went and got him. It was Sam Blue, my daddy [Ben Harris] and Toad Harris [David Adam Harris] and my cousin Sallie Brown [Beck], Lillie Blue and me.

I was only nine years old. I remember it as if it were yesterday. The men sat in the driver's seat on a plank across the body of the wagon. Lillie and I made a tent of the blankets and put a lantern inside to keep warm. It was a long rough ride, and we sometimes peeked out to see where we were. At last we felt the wagon stop, and we recognized that place beyond Van Wyck, not far from Four Acre Rock. This was near the old Indian burying ground.

The Steven name is old among the Catawba. A tribal member named Little Steven served in the War of the American Revolution. The term "little" indicates there must have been an older Steven. Next in line was Lewis Steven, who signed several Catawba leases with the rank of lieutenant, a minor tribal official similar to today's councilman. Lewis was married to Harriet Steven. Their son Thomas was born sometime between 1795 and 1815. Next came Joseph Steven in 1818 and Polly Steven in 1831.

In 1847, Tom and his father Lewis signed a petition stating that they wanted to remove to Indian territory. They were living among the Cherokee in North Carolina at the time. In 1849 the family was still living in Haywood County, North Carolina. Tom Steven did not serve in the War Between the States, probably because of his age. Agent John R. Patton listed him in his 1862 census as living on the reservation in York County. During Reconstruction and as late as 1881, Tom Steven received his share of the appropriation money. There is no record that he ever had a wife. Perhaps Daisy did not live long enough and was not married to Tom Steven long enough to leave a record. In 1883, he was living off the reservation as a tenant farmer. In 1902, he and James Watts were running the Cureton Ferry between York and Lancaster Counties.

Perhaps the most comprehensive record of Tom Steven is found in the 1900 federal census. He spoke Catawba and English, but could not read or write. He was living with Sarah Ayers Harris and her two sons, James Harris and David Adam (Toad) Harris, both of whom became chief of the Catawba. It is supposed that Sarah Harris was closely related to Tom Steven, perhaps his half sister. The Catawba Plat Book points toward a close alliance between the Steven and Ayers families.

Tom Steven was a Catawba traditionalist. Catawba was his first language. He was of slight build, had long gray hair that hung down to his shoulders and he

The Death of Tom Steven

walked with a cane. No known photograph of him has survived. He was the last Catawba to organize Stomp Dances on the reservation, and he formed the basis for the music that Chief Sam Blue preserved. Although not a lot is known about Tom Steven, he was largely responsible for what remains of ancient Catawba song and dance.

Originally published as "Tom Steven Remains a Bit of Mystery," *The Herald*, April 13, 2000.

The "Accidental" Death of Harvey Blue

This material was taken from the Catawba Memory Book Project, an ongoing effort begun in 1980 intended to preserve an archive of Catawba folk memories. Over fifty senior tribal members of the Catawba Nation participated in the initial project. Work continues today under the umbrella of the Big Head Turtle Video Project, which endeavors to accomplish the same goals, but in digital video format. In the original project a number of senior tribal members had vivid memories of what happened to John Harvey Blue. Together these statements give us a full account of what happened on that fateful day.

Trouble at Church

Now what happened, my oldest brother-in-law, he was a Blankenship. He married my oldest sister, my half sister. They was over there at the church one evening—one Sunday evening—having a meeting. This fellow [Wesley Harris] brought this boy up [Walter Harris] and wanted to start a fuss with Harvey. [Walter Harris] told Harvey, he says, "I could throw you down." My brother Harvey said, "No, sir, you can't do that," he says. "I believe I could throw you." "Well just do it to me then," Walter says. [Harvey then said], "Well, I don't want to try it." Said something like that. So Harvey got up, and when he done that, Walter grabbed him and throwed him. [Then] my brother throwed Walter and sat on top of him and held him. And the old man [Wesley Harris] he was standing up there and this old boy says, "Get up and turn him loose." And Harvey got up, and Wesley got his son Walter and says, "Come on, son, let's go. We'll get even with him one of these days." So my brother-in-law was sitting there, and he took Harvey into the church where my dad was, and he told my dad what happened.

This account comes from Catawba tribal member Leroy Blue of Rock Hill, South Carolina, in 1982. The wrestling episode cannot be dated; however, the

The "Accidental" Death of Harvey Blue

The Blue family kept a number of mementos of the death of Harvey Blue. One of them is his portrait, taken a couple years before the boy's death. *Courtesy of Elsie Blue George, Harvey's sister.*

match may have occurred in July 1913. The Indians were paid their state "draw money" on July 6 or 7, 1913. That same night there was a program in the church. While the entertainment was in progress, John and Early Brown (father and son) got into an argument with William Sanders, and Will Sanders was seriously injured with a knife. For several days he lay in Fennell Infirmary in Rock Hill in critical condition. It is possible, even likely, that Walter and Harvey had their altercation that same night. In any case, the seeds for future friction were planted at some time in 1913.

The Fateful Day

January 7, 1914, began as any other day on the quiet Catawba Reservation. Harvey Blue had been staying with Margaret Brown, his paternal grandmother.

> *So, well a few months after* [wrestling at church] *in the winter time, hunting season came in, and Harvey was staying with my grandmother. He killed a*

Two Indian boys going hunting. Courtesy of the Thomas J. Blumer Collection.

The "Accidental" Death of Harvey Blue

rabbit early that morning, real early. It must have been about 7:30 that morning. The dog was out there running a rabbit, and Harvey killed it. He went and dressed the rabbit, and he went down the hill and carried two pails of water for her, and he cut the wood up for her to cook with—the stove wood. He cut that up, had a pile there. And then he told grandmother, "Grandmother," he says, "I believe I'll go with my Uncle John bird hunting. I'd like to see if I can kill a bird." Well, he never was able to shoot a bird. The birds excited him when they'd fly up. So he said, "I believe I'll go with my uncle to see if I can kill some birds." So he went over to Uncle John's and went down the hill past the spring with his shotgun over his shoulder. He had an old 16-gauge single-barrel shotgun. When he left he was singing: "God be with you 'til we meet again. By his counsels guide, up-hold you. With his sheep securely fold you. God be with you 'til we meet again. 'Til we meet, 'til we meet…God be with you 'til we meet again."

He sang that song until he got out of sight. He went down there and caught up with Uncle John, and they went on up there in the bottoms, and a covey of quail got up. They sighted them, and the dog pointed them. Then Harvey got up, tried to shoot them, and he couldn't shoot them, and the birds got away. So he missed them. He told my uncle, said, "The boys up there—it looks like they are hunting rabbit or squirrels. I believe I'll go up there." He says, "I can't kill no birds." So Uncle John says, "Come on son, I'll kill the birds and give them to you." So Harvey says, "No, I want the game I kill. I want something I killed. I don't want something I couldn't kill." Uncle John kept on after him, he says, "Come on, I'll help you. I'll let you shoot first." Harvey says, "I done tried it, and I can't kill them." So Uncle John says, "Well, go ahead then."

And my brother went on up the creek where them fellows were up there hunting, and that's where they took advantage of him at, right there in that woods up there. He got to them, and they ended that little squabble they had down there at the church they had that day wrestling.

In his determination to bag some game, Harvey joined the larger group. The hunting party included three older, more experienced hunters: Wesley Harris was about sixty years of age, Early Brown was twenty-three and John Idle Sanders was twenty-two. The fourth hunter was Walter Harris, Wesley's son, who was twelve years of age, one year older than Harvey. "Them boogers said it was in a den in an old hollow tree, and Harvey clumb the tree," said Heber Ayers of Clover, South Carolina, in 1982. Experienced hunters such as Willie Sanders of Lexington, North Carolina, still wonder why Harvey climbed the tree. Two Catawba, Georgia Harris and Landrum George of Rock Hill, recall that Harvey was offered money.

Leroy Blue continued the story:

Walter Harris and his wife, Lydia. Walter migrated to Pocatello, Idaho, to escape the memory of his friend's death. *Courtesy of the Walter Harris family, at the Thomas J. Blumer Collection.*

The "Accidental" Death of Harvey Blue

Idle Sanders told me how it happened two or three years before he got sick. He said, "I haven't told nobody but you. You're the only one I've ever told. I wouldn't even tell your dad, but you're a young man. You can take it a whole lot better than he could." We were standing right in front of my house when he told me. "Wesley Harris that shot him promised him a brand new pocket knife, if he got up in the tree and run the squirrels out of the tree, and Harvey asked Wesley, he said, 'Well, don't shoot while I'm up there.' Wesley told him, he said, 'We ain't going to shoot 'til you run the squirrels out. We ain't going to shoot.' So Harvey laid his gun down and went up the tree. The squirrels ran out of the nest and Wesley Harris stood on one side of the tree and Walter Harris stood in front of him. 'Come on boy,' Wesley says, 'let her go.' Harvey hollered, 'Lord have mercy, don't shoot me. You promised you wouldn't 'til I get down.' And by that time the guns went off. Harvey fell out of the tree, about 25 feet from the top to the ground, and Walter Harris ran up there and took the knife out of his pocket and took it back and called the dogs then and let the dogs lick the blood off his face. Idle Sanders called the dogs off Harvey, and then he slipped out of the woods and run. He run home and went over to John Brown's (his daddy-in-law) and says, 'Your boy,' he says, 'killed Harvey a while ago.' And Early's mother says, 'Lord have mercy, I didn't know my son [Early Brown] was going to come to be a murderer.' And the old man told her, 'Shut up or I'll beat the hell out of you.' So that was my dad's half brother, John."

The truth was simple to Idle Sanders. All three men had fired their guns. Lula Blue Beck of the Catawba Nation recalled the story this way in 1982:

It's a wonder mama hadn't died herself. I don't remember how old I was, but I remember going up there when ever he got shot. Irvin Gordon's sister Ruth [Ayers] came and told mama. They called him Whiteman. He was always fairer than the others. She said, "Whiteman got shot a while ago." And mama jumped plumb off the porch there, and they tried to get her not to go. It was way up there on what they called York Branch, over on the other side of the reservation, but she went. I remember I carried—it was Scotty I think. I had to carry him and walk a piece way over to old Billy George's place. And they had a saw mill in there, and those old pine trees was cut down across the road, and mama would crawl under one, and some of them she'd climb over the top of them. It's a wonder she hadn't died herself. [Louisa Blue was seven months pregnant.] It was a long ways there and back where he was at. When I got up there with Sally Gordon and my grandmother [Margaret Brown], mama was laying down beside Harvey. He was dying I think, but mama wouldn't get up.

As they made their way through the woods, Harvey "tried to say something but he'd spit up part of his liver—part of his liver would come up. Never did get to tell what happened," Leroy Blue related in a telephone interview on June 17, 1989. When they reached the house, John Brown immediately left for Rock Hill to find his brother Sam. Harvey's father had taken a load of firewood to town that morning and was in the process of selling it, recalled Leroy. The reservation was a long eight miles away, and even under the best of circumstances, travel was slow over the rutted dirt roads. Once the two brothers met, Sam Blue sent John Brown to find the best doctor in Rock Hill. Sam Blue then headed for home with a burden of heavy thoughts.

Leroy remembers that Dr. Frank Massey was not far behind.

> He drove an old Essex way back years ago then. He walked into the house, looked at that boy, and says, "Well [Sam], he won't live long." Dr. Massey gave him a shot of morphine, stuff like that. A dose of morphine and says, "He'll live 'til about 5:00 this afternoon, and then he'll pass away. When that stuff dies out," he says, "he'll be gone." Both of his eyes was shot out. His right lung was shot all to pieces, half of his liver. He lived 'til 5:00 that evening, and he passed away.
>
> Dad wanted to get ahold of that fellow [Wesley] so bad. He left the house and went down to the woods. He had a little tree down there, a little white oak tee with a limb about—the end turned up. My dad always was a religious fellow, and he always said a prayer. And he said his prayers with his family. So he went to that very spot, and he knelt down and asked the Lord to help him. So he would control his self and not take evil. So after he got through praying, he got up and started back to the house and it happened again. [The voice said], "Sam, if you don't kill that fellow who killed your son, you're a coward." And he went back and prayed again. He went back several times, and every time he started back up [the voice said], "If you don't kill him, you have a yellow streak in you." He went back in the woods seven times and said, "Lord, if I ever need you now, I need you worse than I ever did in my life." He says, "I don't want to take nobody's life." So the Lord answered his prayers, and he went back to the house, and put his arm around that fellow and shook his hand. Well, the mail come by about that time, and a telegram came from Atlanta [from the Southern States Mormon Mission]. "Brother Blue, what ever you do, don't take vengeance. Let the Lord handle it." He says, "The Lord will take care of you." So my dad didn't bother him, and he said, "I'm sending you enough money to put your boy away." So he put Harvey away.

The picture of Sam Blue praying in the woods is a pitiful one. The scene has allegorical qualities. Sam, an unjustly hurt father, struggles to maintain his strong inclination to do good and heroically shuns evil. He knows right from wrong, but his

The "Accidental" Death of Harvey Blue

loss is too great, too irreplaceable to be shelved quickly. His sinister side speaks of immediate blood payment. Those who killed his son, a mere child, must pay. Seeing one of the men in the yard pushed Sam to the brink of "let the Lord handle it."

The jury included Chief David A. Harris; ex-chiefs William (Billy Bowlegs) Harris, Robert Lee Harris and Lewis Gordon; Councilman Ben Harris; and tribal members Taylor George, William Sawyer, Henry Canty and Frank Canty. The tenth member was Farris Blankenship.

Landrum George stated in 1982,

> *Harvey had three or four different shots* [in his body], *and one shell isn't gong to have but one size shot unless you take it open and put it in there. They claim he had two or three different size shot in him, and they kind of figured though about the ones that shot him.*

It is difficult to say what an impartial inquest panel would have concluded. Apparently Idle Sanders never fired his gun. No one implicated him and the Blue family had little difficulty in accepting his role as a mere witness. Wesley Harris was the oldest in the hunting party. He should have been looked upon as the most responsible. Traditionally, however, the Catawba would have respected Wesley's age. Also, just six months before, in July 1913, Early Brown had been arrested and charged with assaulting William Sanders. Early Brown could not afford to be sent before a judge in York County again so soon. Early was also Sam Blue's nephew. Walter Harris was a minor, and it is tempting to view Walter as an easy target.

While the matter was being investigated by the court, the Catawba made their own speculations. Some of these are preserved in folk memory, like this one made by Heber Ayers in 1982:

> *It looked like they could have waited. Course squirrels is fast. It could have been an accident, but I say it was purpose cause that's stupid shooting squirrels in a tree while they boy was running them out of the tree. They should have waited until they go on the next tree if they was using their heads.*

Wesley Harris's actions looked bad. He was determined to have the affair taken out of the court's hands and used tribal politics to influence the outcome of the inquest, according to Leroy Blue:

> *So after Harvey died, some of them were on Wesley Harris's side. Wesley knew these people. He went and talked to them to tell the inquest it was an unavoidable accident. Well, they swore to it. Well, they* [the hunters] *was alone, the boy with them. Walter Harris claimed he didn't shoot, but after they examined him, he did shoot.*

Walter Harris's situation was a classical case of a boy facing an adult world. Although Walter was not in a position of responsibility on January 8, 1914, his part in the hunting party was convenient. The courts would look more kindly on Walter, and the incident was ruled an accident anyway. In placing the blame on Walter, the Catawba were spared a prolonged trial. Walter's boyish attempt to escape full blame and deny that he fired his gun only to have it proven that he had fired a shot made him look more guilty than he might have been. The Blue family realized that Harvey could not be brought back.

The Blue family had little time to mourn their loss. Louisa Blue was seven months pregnant when Harvey died. She naturally forgot her condition at the moment she heard of Harvey's plight. Louisa was so upset that she reached Harvey first. Upon seeing her boy, she swooned. The family naturally feared that Louisa might give birth prematurely. Some, like his sister Lula Beck, feared that the baby might be marked by Harvey's blood. Louisa gave birth to a healthy, unmarked baby whom she named Elsie on March 21, 1914. Today, Elsie George recalls that she was always frightened when she heard a gun go off, and she wonders if this fear might be linked to Harvey's death:

> I never could stand to hear a shotgun go off. I always wondered if that might have been caused by that. Daddy always killed a chicken with a shotgun. We raised game chickens, and you can't catch them. They'll fly a mile. The easiest way is to go out and shoot one.

Although the incident had been declared an unavoidable accident, the Catawba speculation continued. Nine months later, in October 1914, Wesley Harris lay on his deathbed. According to an interview with Marvin George in 1982, it was time for Sam Blue to take the second step to forgiveness:

> Wesley Harris had taken sick. So old man Harris called dad to come down and see him. Dad went, shook hands with him. He says, "I'm sorry I lied to you what we done." He says, "I'm paying for it." He says, "That was just pure meanness…We done it, and I want you to forgive me." And dad says, "I forgave you, and its up to the Lord for the rest." Well, his boy, Walter, was sitting there, and he was a young fellow, and he didn't have much to say.

Naturally, Wesley Harris felt that in confessing he had cleared his conscience. His relief must have been tremendous. Also, however brief the conversation was, Sam Blue had an opportunity to face Wesley and discuss Harvey's death openly. The lamentable episode seemed closed, and it would have been had Walter not been a witness to this touching scene. Walter left no comments on how he felt at

The "Accidental" Death of Harvey Blue

that moment or during the years that followed, but he was only twelve years old and had to go on with his life. Evidence of Walter's smoldering hurt does, however, remain. When Wesley Harris died in 1914, young Walter was left the family's sole support. Four years later, at the age of sixteen, he found work in a local cotton mill. One night after work, probably on payday, Walter went out on the town with several coworkers, both Indian and non-Indian.

Leroy Blue spoke of this event in an interview in 1982:

> So one day Walter Harris and my brother Herbert was working together up here in a little old cotton mill. Up here what they call Highland Park in a dye house. We [all] just worked 15 feet apart maybe 20. One week me and Walter got off and went out with a bunch of fellows, and they got in a fight with somebody. And Walter told this fellow, "Well, I killed one fellow and got by with it, and I can kill another one and get by with it." That's when I come back and told my brother Herbert about it, and my brother went there and asked him, "Did you really say that?" Walter said, "No, sir, I don't remember saying that. I sure don't remember saying that." And Herbert said, "Well, if you did say it, I'm going to put you away for good. I'll put the law on you, have you locked up and put away for good if you said that." Walter says, "I didn't say it."

In 1931 Walter Harris moved to Pocatello, Idaho, but he never really stopped thinking about Harvey Blue. The story he told in later years, included in Mamie Anderson's *Life Sketch of Walter Beauregard Harris*, was part fact and part fiction:

> They were—a bunch of these kids were out shooting squirrels, and Harvey went up to try to scare the squirrels out or something. And they were all shooting, and he fell out, got shot and nobody knew who did it. But since Walter was the youngest, the others decided—well—Walter was the scapegoat. So that's what Harvey's father and folks want to believe—what they accepted anyhow. Walter was the one who got blamed for it. Walter didn't put them up to it. Walter wasn't even with them when it happened. I know you've heard their version, but that is what we know about it.

Today the Catawba still talk about Harvey Blue. The boy made no real mark on history before 1914. His birth date was recorded in the family Bible, the census taker noted him as part of the Blue family and he was photographed twice. In the Smithsonian photograph he is only identified as a Catawba. Harvey's scant documentation would have sufficed for many years, at least until he had his own family and perhaps became active in the tribal government. Because Harvey died a violent death his name is part of the Catawba folk memory. The events surrounding his death are filled with drama and allow us a unique focus on one day among the

Catawba. We can talk about January 8, 1914, only because of Harvey. We will never really know what went through the minds of Wesley and Walter Harris and Early Brown and Idle Sanders as Harvey climbed the cedar tree. We can imagine that Harvey was proud to climb the tree. He loved to hunt squirrels, and he had a fine new penknife in his pocket, payment for his willing effort. At the same time, it is hard to imagine that Wesley and Walter would have plotted to injure Harvey over a simple wrestling match. Wrestling was a much-enjoyed pastime, and each match ended with one winner and one loser. Tempers often flared.

An interview in 1982 with Rock Hill resident Georgia Harris put the events in what might be proper perspective: "You know how people get excited when they see something, and they just pull." It goes without saying that Harvey Blue never should have climbed that tree with four guns pointed at him. There is so little between a trigger and the finger pressed to it in anticipation. Harvey Blue's siblings still mourn the loss. Elsie George treasures the "corduroy cap that fit over his ears. It was cold weather, and them shots went through the corduroy cap. It had flaps over the ears," remembered Leroy Blue.

Taken from an unpublished manuscript in the Blumer Catawba Archives, University of South Carolina, Lancaster.

The Great Flood of 1916

The Catawba River, until flood control was developed, was a constant problem for the Catawba who farmed in the river bottoms in the heart of the flood plain. While it is true that the reservation has some good bottomland, floods were so frequent it was difficult for the Indians to harvest a crop with any certainty. Perhaps the most destructive flood and that most remembered by tribal elders today is the Flood of 1916.

The rains began when a hurricane passed over York County on July 15, 1916. The rain was heavy and much damage was done to growing crops. By the next day, the Catawba River was in full flood. Crops in the river bottoms were inundated. County bridges and railroad trestles were swept away. Communication was destroyed to the north and east of Rock Hill. Train service was interrupted.

Newspaper accounts tell of great quantities of cotton floating down the river. People went to safe vantage points on the riverbanks to watch the drama of the Catawba River in rampage. Bertha George Harris sat at such a lookout place with her grandfather, Taylor George, and watched the railroad trestle near Fort Mill collapse.

Communications were cut on the Catawba Reservation. Old roads were under water, and the Indians had to take new paths to get from one place to another. One account of this episode was provided by the late Georgia Harris. Her grandfather, Epp Harris, had died just a day earlier. As a result, young Georgia was expected to spend the night with her grandmother, Martha Jane Harris. Unfortunately, Martha Jane's house was at the edge of the river bottoms. Georgia and her grandmother spent the day watching the river surge past Martha Jane's one-room log cabin. Georgia was terrified that the water would reach the house and sweep the two of them away. She had watched entire houses float down the river. The thought of sleeping in that cabin was too much for young Georgia to handle.

Epp Harris kept a rock at the river's high mark. Martha Jane took her distressed granddaughter and showed her the rock. She explained that the river had never passed that marker, not even in the Sherman Flood of 1865. Martha Jane promised

Georgia that if the water covered the rock, they would leave for higher ground. Georgia struggled to remain content with this thought.

The promised safe haven was the home of Georgia's mother and siblings, which rested well above the flood plain on dry ground. Young Georgia was, of course, not fully content with this promise. As a result of Georgia's worries, the two got up out of a warm bed several times during the night, lit a lantern and walked down to the rock. Finally, toward dawn, the water began to recede. At last Georgia Harris felt safe enough to enjoy some sleep.

When the flood was over, the Catawba had some meager opportunities for economic gain. Chief David Adam Harris left a written account of those drama-filled days. Punctuation has been added to the document, which was written in one long sentence. Chief Harris's spelling peculiarities are preserved as indicators of his pronunciation.

> In the year 1916 a big flood cam in the Indian Reservation. Homes got washed away: barns, cow stables, bridges, railroad tracks. Bales of cotton also got washed away, too. People risked their lives trying to fish out bales of cotton. Some of the Indians got killeld and washed away too. It took thirteen months to build it back. You could go down some place on the river and find some bones of the Indians.
>
> It happened at the time of the flood Chief Blue of the Indian Resvation help to fish out bales of cotton. His brother [John Brown] also help him. At that time a agent was elect and gave $15 a bale of cotton that washed away, so Chief Blue had $45 in all. Warehouse got washed away, two mills boats stand too.

There are many oral histories that touch on this great flood. One of the most vivid was left by the late Sallie Harris Wade after a 1986 interview:

> Oh, I can tell you it was a scary thing. It was in 1916, and it looked like to me it rained about a week. It certainly was a flood and a bad one cause I stood over there by the trees, you know [pointing to the bottoms at the edge of her yard]. It was washing the roadside cause it come way back up to here and I'd cry. I was thinking it was going to come up here to our house, but [it] never did get up there.
>
> If you could get to the river, houses went down the river. You could see people on top of the houses hollering. They would want you to come and get them. There was lots of stuff washed down that people got. There was a lot of cotton, bales of cotton that was left in the bottoms. People took it out and dried it and sold it. I was scared then.

Train service was interrupted, and it took a long time to repair the Seaboard Trestle between York and Lancaster Counties. A number of Indians found work in

ferrying passengers from a train that stopped on one bank to meet a train waiting on the other side. Many people refused to get in a boat ferried by anyone other than a Catawba.

Sallie Wade felt that a boat manned by a Catawba could have tipped over just as easy as a boat propelled by anyone else, but some people thought that they were safer with an Indian boatman.

Originally published as "Remembering the Great Flood of 1916," *The Herald*, December 23, 1999.

Influenza Epidemic of 1918

In 1998, modern scientists took biopsy specimens from victims of the Spanish flu, which ravaged people on five continents in 1918. The site of this specimen retrieval was a mass grave at Eskimo mission at Brevig, Alaska. In one week Brevig lost 85 percent of its population to the disease.

Today we know this tragedy originated in the so-called swine flu, the most deadly strain of influenza ever known to hit the human population. It is thought that the epidemic was spread by American troops mobilized for World War I. The reservation area faced the disease in September 1918. The local health commissioner claimed there was no cause for alarm. A month later York County faced monumental health problems. Public schools and other public meeting places were closed on October 5. Public gatherings were forbidden, yet the officials claimed that was no cause for panic. Children were forbidden to congregate. Winthrop College was quarantined and churches were closed on October 8.

The Catawba Reservation felt the epidemic immediately. The family of John and Rachel Brown suffered the most. The first of their children to die was John William Brown on October 4. Maggie Brown died the next day; she had married Richard Harris just two years before. He was on the front in the European war. John and Rachel Brown buried their third child, Ethel Brown, on October 8. The next day, the Brown family lost Cora Brown Sanders. Her young husband, Ernest Sanders, was also away serving in World War I. Cora's infant child, Melvin, died on October 10. According to accounts from tribal elders, several times John and Rachel Brown went to the cemetery to bury a child only to return home and find another dead.

The Red Cross worked against tremendous odds to help the sick. Efforts were made to educate the public, recommending bed rest, isolation of the patient, the burning of all body excretions, the administering of plenty of water and the use of gauze masks while tending the sick. To manage the problems on the reservation, the Red Cross set up a military tent. From this headquarters, assistance was sent to

help families. The Catawba also did what was customary in aiding the sick within the tribe.

Sallie Harris Wade and her father never took sick. Sallie went to Rachel Brown's side and tended her children. Years later, Sallie Wade recalled with a note of profound sorrow, "She had a bunch of kids. So it just wiped her family out. Lost a grand baby too."

The last death the Catawba suffered was in the family of David A. Harris, who lost a son on October 14.

Today the Catawba still talk about the events of 1918, particularly the sorrows faced by John and Rachel Brown. Furman Harris remembers going to Cora Brown Sanders's funeral. His sister Georgia Harris took him. Cora and her son died so close together that the young mother was laid out with her baby, Melvin Sanders, in her arms. Others recall constant trips to the cemetery to put away yet another deceased member of the Brown family.

Sallie Brown Beck was one of the Brown children who survived. Catawba informant Rachel Beck Yates recalls her mother's thoughts on those hard days. "Mama was talking about the great flu epidemic, and she said that she was sick and knew nothing about what was going on around her. When she finally came to, she discovered that her brother and several of her sisters had died from it. There was Jack, Cora, Ethel and Maggie. Ernest Sanders was in Germany, and his wife Cora died and his son Melvin too. By the time mama came to, they were all buried."

On October 28, 1918, a notice appeared in the newspaper. The Red Cross had received a telephone message from the Catawba Nation. The message reported no new cases and that all those suffering from the flue were improving.

The results of this epidemic were catastrophic not just among the Catawba. Some twenty-one million deaths were recorded around the world.

For the Indians, the final chapter was written by Ben P. Harris on November 4, 1918, in a short newspaper article:

To the editor of the Record:

We take this method to thank the kind ladies who represented the Red Cross in visiting the sick and ministering to their needs, during this recent epidemic, which came upon the Indians of their present reservation. When those kind ladies appear before the just judge, He will say to them, "I was sick, ye visited me; I was hungry, and ye fed me, in this you shall in no wise lose your reward."

Respectfully,
Ben P. Harris, Catawba Indian

In the years after the epidemic, John and Rachel Brown took money earned from running the ferry on the Catawba River and money Rachel earned by peddling pottery and purchased cemetery monuments for their children. Today, one can still stand in the cemetery on the old reservation and meditate on this sad chapter in Catawba history.

Originally published as "Flu Left Scars on the Nation," *The Herald*, March 9, 2000.

Citizenship

One of the great ironies of American history is that our vast Native American population did not have United States citizenship and hence the right to vote until well into the twentieth century. The Catawba Nation of South Carolina had to wait longer than most Indians to gain this right. The story of the struggle of Catawba tribal members for citizenship of the country they once owned is a long one.

The first Catawba to seek such citizenship was a Catawba/Pamunkey named John Marsh. His case may be found in the *Reports of Cases Argued...State Reporter,* vol. 1 (May 1828–June 1830), 215–16. John came from good stock. His story may be linked to his father's (Robert Marsh) application for a United States Revolutionary War pension. As an Indian, John's father's application was challenged, and he had to provide definite proof that he was a veteran of that war. Marsh attended the College of William and Mary's Indian School and was a Baptist missionary with John Rooker around 1800. John Marsh grew up under the influence of this man.

The Marsh family knew something about the law. Marsh filed in the court under *The State ex rel. John Marsh v. The Managers of Elections for the District of York.* All the judge had to say was that John was not a free white man. The judge neglected to mention his education and that he was the holder of a Catawba lease, a landowner. The opinion of the court reads in part: "It is with regret I find myself obliged to declare, that by the laws of this State, the applicant is not entitled to a vote."

We know nothing of the Catawba reaction to this news. Certainly most were not in the least surprised at the judge's decision. Another coincidence is that this decision came at the same time that Columbia was jockeying to purchase the Catawba Reservation and hence leave the Indians without an income.

In answer to the judge, we might cite the Catawba war record from the two Tuscarora Wars, the solution of the Yamassee War, the American Revolution, the War of 1812 and the Seminole Wars. In 1822, Peter Harris of Robert Marsh's generation penned his few comments on the Revolutionary War:

I am one of the lingering members of an almost extinguished race. Our graves will soon be our only habitations, I am one of the few stalks, that still remain in the field, where the tempest of the revolution [has] passed, I fought against the British for your sake, the British have disappeared, and you are free. Yet from me the British took nothing, nor have I gained anything by their defeat. I pursued the deer for my subsistence, the deer are disappearing, and I must starve. God ordained me for the forest, and my ambition is the shade, but the strength of my arm decays, and my feet fail in the chase. In my youth I bled in battle, that you might be independent, let not my heart in my old age, bleed, for the want of your commiseration.

In spite of these facts, no one was concerned about Catawba welfare until 1909, when South Carolina Governor Martin F. Ansel felt a twinge of conscience. A letter of December 20, 1909, reads:

I herewith enclose a list of the Catawba Indians made for me by Mr. J.D. Lesslie, Agt. I went down to the Nation and had a talk with the Indians. They are unanimously in favor of being made citizens they say if they can get a square deal...I think it will be best for the interests of the State and the Indians also to have them made citizens.

Three days later the Catawba signed a petition that they be granted citizenship. This petition was signed by all the tribal male members of influence: Sam T. Blue, Lewis Gordon, James Harris, Robert Lee Harris, John Brown, David A. Harris and Ben P. Harris.

The idea reached the South Carolina legislature in 1910, where it languished. In February 1910, some fifty-one Catawba (all members of the ancient Catawba General Council) signed a similar petition for citizenship. The next year, the Catawba Commission recommended citizenship for the Catawba. This recommendation went by without legislative interest.

On November 6, 1919, the United States Congress gave full citizenship to all American Indians who had fought in World War I. This came about in Public Law No. 75. Several Catawba who had served in the war were granted citizenship by this public law but South Carolina acted as if no change had been made. Aware of the existence of Public Law No. 75, the Indians petitioned for United States citizenship again in 1920. A formal bill was submitted to the South Carolina Assembly in February 1924, only to be killed on February 6, 1925. A response was that the commissioner of Indian Affairs declared the Catawba were citizens of the United States, but in May 1925, this right was denied by the State of South Carolina.

This legal wrangling happened in spite of Public Law No. 75, which is the most far-reaching citizenship law ever passed by the United States Congress. It granted

citizenship to all American Indians born within the territorial limits of the United States. The situation for the Catawba did not get any better. The next Catawba to act on behalf of his tribe was Robert Lee Harris. Harris was gifted with a great intelligence. He had his opportunity to have his case heard in the Senate hearing held in 1930 in Rock Hill. Some of the minutes read as follows:

> *Senator Thomas: Aren't you now citizens of the United States?*
> *R.L. Harris: We are citizens of the U.S., but not the State of S.C.*
> *Senator Thomas: You are not citizens of S.C.?*
> *R.L. Harris: No, sir; we are citizens of the U.S. altogether.*
> *Senator Thomas: Do any of your members vote?*
> *R.L. Harris: We can vote for the national ticket, I suppose, but State won't let us have anything to do with it.*
> *Senator Thomas: As a practical proposition then, you do not vote; is that correct?*
> *R.L. Harris: That must be it.*

The Catawba requested U.S. citizenship again in 1937. In spite of this denial of the rights granted to the Catawba, over forty Catawba men went to fight in World War II. The Catawba refused to let the issue die, but it languished. In 1943 the Catawba signed a "Memorandum of Understanding" under Chief Robert Lee Harris. The signatories were the Catawba Nation, the State of South Carolina and the United States of America. As a result of the memorandum, South Carolina reluctantly passed Act No. 398, An Act to Confer Citizenship Upon the Catawba Indians. Regretfully, the issue was not dead. In June of 1946, the names of thirteen potential Catawba voters were removed from the Democratic Party rolls by the Democratic Executive Committee of York County. In response, the Catawba General Council directed its executive committee to discuss the matter. Three years later, the Bureau of Indian Affairs agent W.O. Suiter reminded South Carolina of the "Memorandum of Understanding." For the first time, seventy-seven Catawba tribal members voted in an election. South Carolina could rest easy with this fact of life and in September 1955, South Carolina retaliated and demanded that the Indians pay for auto tags, a small price the Catawba had to pay for the right to vote and some influence on their destiny.

Originally published as "The Catawba Road to Citizenship, 1909–1949," WRHI-FM, Rock Hill, South Carolina, April 30, 1998.

Chief Raymond Harris

Raymond Harris was born on November 6, 1913, the son of Chief David Adam Harris and Della George Harris. His first years consisted of ordinary childhood lessons, trips to Sunday worship and warnings that he'd best come in after dark lest the wild Indians get him. This world dominated by a protective mother came to an end in February 1917 when Della Harris was shot by Chief David Adam Harris. Raymond was four years old. When he was barely past five, his father was acquitted of murder in the killing. But the turmoil of his mother's death continued to haunt Raymond. He was first raised by his sister, Artemis Harris, and later by yet another sister, Isabelle Harris. Along with the nurturing provided by his other siblings, Raymond was lucky to live in a close reservation community. He was surrounded by loving family and tribal members who were eager to help him reach manhood.

The year 1933 marked a turning point in Raymond Harris's life. On June 7, he married Nola Harris, who was fifteen and well on her way to becoming a master potter. He is also remembered in tribal annals as a star member of the Catawba Baseball Team under the pseudonym Rainbow Harris. The next few years were spent establishing his own family and enjoying a family life that he had missed since 1917.

Disruption again set in when World War II broke out. Raymond followed Catawba tradition and joined the United States Army. For the first time in his life, a young man who had seldom left the reservation traveled across the country to a number of military bases: Fort Bragg, North Carolina; Camp Shelby, Mississippi; and Fort Benning, Georgia. Raymond eventually saw action in Germany. He displayed his loyalty in spite of the fact that the Catawba were not counted as American citizens by South Carolina.

Raymond Harris came into his own upon his return from the World War II front. The Catawba were eager to elect a war hero as their chief, and the ancient Catawba General Council chose Raymond Harris. It was soon evident to the tribe's membership that they had a dynamic leader.

Chief Raymond Harris

Chief Raymond Harris as a new recruit in the United States Army. *Courtesy of Deborah Harris Crisco, Raymond's daughter.*

Above: The New Catawba Indian School, built in the 1940s during the tenure of Chief Raymond Harris with combined federal and state money. *Courtesy of the Bureau of Indian Affairs. Below:* The New Mormon Church, built in the 1950s during the tenure of Chief Raymond Harris. *Courtesy of the Thomas J. Blumer Collection.*

Chief Raymond Harris

Chief Harris will always be remembered for his passion for construction and zealous leadership at a critical juncture in Catawba history. His accomplishments were realized during the early federal warship period, but it must be remembered that even under the protection of the United States, the Catawba had little money to spend on construction. At one point during his tenure, the tribe had $704.37 in a checking account and $1,000 in savings. The first task was housing. Chief Harris urged tribal members to abandon their substandard housing on the old reservation, but families were often reluctant to leave land they had considered home and the closeness of life on the old reservation. As they agreed to move onto new land, Chief Harris saw to the construction of more than thirty new houses. Other dwellings were improved.

By the 1940s, the Catawba Indian School built by Chief James Harris in 1897 was crowded with pupils. Chief Raymond Harris guided the Catawba Nation through all the problems of building a new school. First the General Council reluctantly accepted a controversial site on new reservation land. Then the money had to be obtained. In 1949, South Carolina appropriated $13,000 for the project and the United States matched this amount. When the first classes were held there in the fall of 1949, Chief Raymond Harris had every right to be proud. During this entire period, he stubbornly faced the York County School District, which refused to allow Catawba children who attended school in Rock Hill to ride the school bus. The contention was that their Catawba parents did not pay school property taxes. In 1949, Chief Harris led a group of seventy-nine Catawba who sought the right to vote and resolved yet another crucial Catawba citizenship issue.

The next problem Chief Harris faced was a new church. The new Catawba Indian School relieved some pressure for a temporary place of worship. Church services were held in the school auditorium while money was sought to build a new, larger church. The old stucco building on Indian Trail and Tom Steven Road was beyond repair. Also, the General Council had to be convinced that the new church should be on new reservation land. This dispute was coupled with a reluctance to accept a new cemetery adjacent to the new church. In the middle of these negotiations, Chief Harris was diagnosed with cancer. Unable to keep up with his responsibilities, he resigned his position as chief in the summer of 1950. He, however, held onto the hope that he would live to see the new church built and ready for services. Eventually he prayed that his funeral could be held there. He died in January 1952 and the church was opened in March 1952. It was dedicated the following May.

Tribal historian Garfield C. Harris was with Raymond Harris when he died and recorded his death in his "Obituary Journal": "I stood by his bed until the last. No one was with [him] but me." Raymond's funeral was held in the school that he had built. Garfield Harris recorded the hymns sung by his mourning

family and tribesmen: "Oh What Song of the Heart," "Oh My Father" and "God Be with You 'til We Meet." The Veterans of Foreign Wars of Rock Hill provided the color guard and a flag was presented to his widow, Nola Harris.

The Catawba Nation had lost a leader of great talent and ambition, but Chief Raymond Harris left behind many reasons to remember him.

Originally published as "Raymond Harris: War Hero, Chief," *The Herald*, July 22, 1999.

Samuel Taylor Blue

A mong the pivotal personalities in twentieth-century Catawba history stands Samuel Taylor Blue. When discussing Catawba culture, politics and religion with tribal members, Sam Blue's name will always come into the discussion. His name remains respected among the Indians of today. He is still fondly called "Old Chief Blue" by Indians and non-Indians alike.

Sam Blue was born in 1872, the son of Margaret Brown, one of the last native Catawba speakers. He died in 1959 during the tumultuous termination process and was pivotal to its success.

According to tribal records, Sam Blue began his political career in 1905. At that time the Catawba Nation was in a dispute over the recently built Catawba Indian School. A committee was formed to govern the Catawba until a new chief could be elected by the General Council. The committee consisted of Lewis Gordon, Ben P. Harris and Samuel T. Blue. This group supported the election of David Adam (Toad) Harris as chief. Harris was later elected, breaking a deadlock.

In 1909, Sam Blue was one of the signers of a tribal petition/plea for Catawba citizenship of the United States. This request was made almost ten years before the United States Congress granted citizenship to World War I Native American veterans. Sam Blue made a second citizenship plea in 1937, apparently not knowing citizenship had been granted to all Native Americans, including the Catawba, in 1924. (Sam Blue never learned to read and write.) In spite of this federal law, South Carolina forced the Catawba to wait for citizenship another twenty years until March 1944. His long interest in political justice for his people is marked by frequent trips to the state capital in Columbia. While there he always spoke before the legislature.

Sam Blue was elected chief of the Catawba in 1928 and served until 1939. In 1929, he revived the struggle to reach a settlement of the ancient Catawba land claim against South Carolina and the United States. The solution Blue sought was achieved in 1993, nearly sixty-four years later. Blue was also instrumental in the

Samuel Taylor Blue and his wife Louisa Canty Blue on their trip to Salt Lake City. *Courtesy of the Bureau of Indian Affairs.*

tribe's bid for federal recognition, which was successfully attained in 1941. Blue served as chief a second time in 1956.

Though Sam Blue was not chief at the time, he, by virtue of his influence, led the Catawba toward the termination of the federal wardship and the division of the tribe's few assets in 1959. He died that same year and did not live to see a program he favored implemented. A member of a progressive political faction, Blue felt individual titles to each family's allotment would solve many problems. This dream became a legal reality for the Catawba in 1961.

Sam Blue is a key figure in our attempts to understand Catawba culture. He was a follower of Tom Steven and did much to preserve the dances and songs he learned from Steven. These include the Bear Dance and the Wild Good Dance. When Steven organized the last Stomp Dances on the Catawba Reservation, young Sam Blue was always there, eager to learn. In 1939 he won a prize at the York County Fair for his Catawba bows and arrows. That same year, he lobbied for a highway and a bridge on reservation land between York and Lancaster Counties. He felt such a link lined with tourist shops would help potters sell their wares in competition with the Cherokee of North Carolina.

Sam Blue also had a place in scholarly efforts to record the last sounds of the dying Catawba language. He began his relationship with Frank G. Speck as a fluent, but halting, speaker of Catawba. English rather than Catawba was his first language. In spite of this handicap, he assisted Speck in his efforts to record the Catawba language, and his language skills were heightened. When he died in 1959,

Samuel Taylor Blue

the passing of the Catawba language was mourned. Today Blue is the author of one of three audio recordings of the Catawba language that we have today.

He also worked with local historian Bob Ward and assisted Florence Speck in probably one of the earliest efforts to record Catawba genealogy. In the 1950s, he taught Indian lore and crafts at the Nature Museum, now the Museum of York County.

Sam T. Blue was also a leader in the Catawba religious community. He was a staunch Mormon and was sought after the Indians for his blessings, which people firmly believed were listened to by God. When a death occurred, Blue led in tolling the bell. This mournful sound brought the Indians together to begin mourning. He was a frequent speaker at funerals and during Sunday worship.

The consumption of alcohol by the Indians was a sore point with Sam Blue. He followed King Haigler's lead in this and cited the king's eighteenth-century temperance speeches. In 1950, he was Mormon Church president. In April of that year, Sam Blue and his wife, Louisa Canty Blue, traveled to Salt Lake City to a conference of the Church of Latter Day Saints. In 1952, he dedicated a new church on the reservation. His knowledge of scripture was vast, though he never learned to read and write.

Not long after Samuel T. Blue died, his memory was honored through a play, *Kah-who Catawba*. As narrator, Chief Blue, played by Bill McDermont, provided this historical drama with a unifying thread. Chief Blue was in good historical company, for the play included such Catawba heroes as King Haigler, Sally NewRiver and General NewRiver.

Originally published as "Sam Blue," *The Herald*, February 24, 2000.

Samuel J. Beck
Traditionalist Faction Founded

History records a line of Catawba leaders spanning nearly three centuries. The list, too long to produce here, contains the illustrious King Haigler, General NewRiver and Chiefs Allen Harris, James Harris and Sam T. Blue. These and other served their nation, often during times of stress. Today the Catawba must add another name to their roll of honor: Samuel J. Beck.

With the death of Sam Beck, the Catawba Nation mourned the loss of one of its most capable and dedicated councilmen. His service spanned more than fifty years. As a teenager, he drove a delegation of Catawba potters to Schoenbrun Village near New Philadelphia, Ohio. He played ball for the championship Catawba Baseball Team in the 1930s, and in 1941 he helped establish the first Catawba Boy Scout troop.

Sam's most dramatic contributions were political. He was the first Catawba to attend high school, and Chief Robert Lee Harris sought to tap Beck's training and expertise during the negotiations for the "Memorandum of Understanding." As a result of these contributions, he was elected to the Tribal Council in 1939. He was instrumental in compiling the Catawba Tribal Roll of 1943, the first accurate roll ever published. Earlier ones had been compiled by Indian agents who had little knowledge of the Catawba population. In November of 1943, he was called into the United States Army and served until the end of World War II.

Upon his return home in 1946, Sam Beck reentered politics and was elected to the Catawba Executive Committee under Chief Raymond Harris. He also served with Chiefs Nelson Blue, Ephriam George, John Idle Sanders, Samuel T. Blue and Albert Sanders. From 1973 until his death, he was a member of Chief Gilbert Blue's Executive Committee.

Samuel J. Beck was never afraid to defend what he thought was right. All the Catawba knew that the "Memorandum of Understanding" had not been honored by either the United States government or the State of South Carolina. In 1958, he traveled to Columbia, South Carolina, to put the tribe's grievances before the state officials. The Catawba hoped that support for the long-promised pottery shop was forthcoming. There was also talk of a Catawba pageant. None of the Catawba

Samuel J. Beck: Traditionalist Faction Founded

Samuel J. Beck, 1944. *Courtesy of Helen Canty Beck, Samuel's widow.*

leaders, including Sam Beck, suspected that the 1958 meeting would result in a program as divisive as the termination of the tribe's assets.

Unfortunately, the negotiations quickly shifted from educational and cultural assistance to serious talk that threatened the Catawba Nation's status. The presence of a federal Indian reservation in South Carolina was criticized. Sam Beck saw the Termination Program as an attempt to destroy the Catawba Nation once and for all. He objected and consequently became central to the dispute that followed.

Sam's major concern was to save the Catawba land base, small as it was. He believed that dividing land assets among tribal members would destroy the tribe's viability. He organized the Traditionalist Faction and never hesitated when called to testify before the United States House of Representatives Committee on Indian Affairs in 1959. When we read Beck's comments today, the perspectives gained are profound. He spoke forcefully and sincerely: "I have thought along the lines of benefit to the people and not myself."

The Bureau of Indian Affairs (BIA), which was not legally charged with selling the Termination Program and in fact broke the law in doing so, argued that the Indians could not obtain loans to build new homes or remodel old ones on reservation land. They continued that giving each Catawba clear title would,

in the eyes of Washington's bureaucrats, correct an old injustice. The Catawba would benefit from a wave of lending institutions. Sam Beck saw that title alone would not provide "enough collateral to go to the bank and borrow the amount of money sufficient to make the improvements." He also understood that many of the Indians who did not see private property as a plus would sell their land to sharks immediately. Sam was right on all counts.

Sam Beck became the spokesman for the Traditionalist Catawba Faction. He proposed that the BIA consider a solution that would satisfy both factions, including those Catawba who wanted to cast off traditions they felt were restraints. This later faction wanted little to do with the ancient Indian communal property system. As Beck stated, his solution still has meaning to the Catawba. "I would like to have it shown in the record that I am in favor of a half withdrawal for those who wish to remain on the reservation as they are, and for those who want to have titles to their lands and live as other citizens in the State they may do it."

During the months that followed, Sam Beck continued his efforts to save the reservation. He boldly faced the powers of the BIA. His pleas were ignored, and the Traditionalist Faction stoically became resigned to the inevitable. Washington would have its way.

In 1961, Beck was among those Catawba who refused to make application for their shares of the tribal assets. Although defeat was a fact that Sam Beck and those who thought as he did had to face, all was not lost. The Traditionalist Faction retreated to the tribe's much-reduced land base. Between 1962 and 1973, the Catawba looked to Sam Beck as their leader even though he never sought or claimed the title of chief.

Ironically, both Catawba factions knew they could count on Sam's services. He kept the reservation roads paved and maintained. He virtually handled all tribal business during this decade. According to his widow, Helen Beck, "He knew the right people. He knew how to get things done." Fred Sanders, who served on the Executive Committee with Sam Beck, agrees: "Sam did all the footwork. Even those who lived off the reservation naturally turned to him."

When Gilbert Blue succeeded Chief Albert Sanders in 1973, Sam Beck was on the slate. The new Executive Committee, including Beck, immediately traveled to Columbia, South Carolina, on tribal business. This was only one of such trips. During this period, Sam Beck spent many hours studying blueprints of the Catawba Indian Civic Center. When actual construction began, every day one would find Beck on the center's site supervising its construction.

In 1979, Catawba history repeated itself, and the tribe divided into two factions along traditional and non-traditional lines. The Traditionalists wanted an expanded land base, educational programs and restoration of the tribe's federal status. The other group wanted a simple cash settlement. Sam again supported traditional Catawba ideals.

Samuel J. Beck: Traditionalist Faction Founded

Sam Beck never wavered in his dedication to the Catawba Nation's cause. He attended United States Senate and House hearings in Washington, numerous meetings in Columbia, South Carolina, and all court hearings in Richmond, Virginia. When the Catawba right to sue was argued before the United States Supreme Court, Sam Beck was in attendance listening intently—learning.

Dutifully, he carried his knowledge home to the Catawba people. His messages were delivered in democratically held General Council meetings and often times repeated on a one-to-one basis

Today the Catawba General Council is one of the oldest legislative bodies in the United States. The General Council certainly predates any governing body in South Carolina. Those Catawba who witnessed Beck in action have a great model to follow. He set an example for all Catawba tribal members to follow. His Traditionalist Faction lives on today under Chief Bill Harris and his Executive Committee. The Catawba Nation is not wanting for heirs to the rich tradition that Samuel J. Beck left behind. He will always be an inspiration to his people.

Originally published as "Beck Dedicated Life to Catawbas," *The Herald*, June 17, 1989.

Georgia Henrietta Harris
1905-1997

To put it as simply as possible, Georgia Harris was recognized as keeper of the ancient Catawba pottery tradition. She also was a leader in the pottery revival that began with the Columbia Museum of Art show in 1973. This revival continues to this day and is led by a totally new group of young master Catawba potters, some of whom knew Georgia and worked with her and some of whom only know her through her stellar reputation among the Indians. The culmination of Georgia Harris's career as an artist came several months after her death in January 1997. She is the only artist to be presented with the National Heritage Award by the National Endowment of the Arts (NEA) posthumously. Her work was so fine and so consistently of museum quality that the NEA was nearly forced to recognize the work of this amazing woman.

Once the idea was presented to the Catawba that Georgia Harris was a nominee for this award, people began to work on describing her career. The first individual to send a letter of support, in 1990, was a Native American attorney who at the time was president of the American Indian Bar Association. She is a Catawba descendant and had taken pottery lessons from Georgia Harris. Today Miss Judy Leaming is the attorney for the Coleville Indian Nation Gaming Commission for the Coleville Nation of Washington State. The second nomination, also in 1990, came from Wenonah George Haire, who represented the Catawba Cultural Preservation Project. A third nomination, in 1991, came from Douglas DeNatale, who was South Carolina's folk art coordinator working out of the McKissick Museum, University of South Carolina, Columbia.

I have long considered Mrs. Harris my primary tribal mentor and confirmed her nomination in 1992 with a lengthy discussion of her art, which was accompanied by slides of her vessels in the Blumer Pottery Collection. This collection is now in the custody of the Katawba Valley Land Trust and located in Lancaster, South Carolina, just a few miles from the Catawba Nation's reservation located in neighboring York County, South Carolina. This letter was sent to Leslie Williams of the South Carolina Arts Commission. Quotes from my lengthy letter of support are valuable here:

Georgia Henrietta Harris, 1905-1997

Georgia Harris taking a break from the daylong task of burning pottery in an open fire. She used the stick to move the coals and check her pottery. *Courtesy of the Thomas J. Blumer Collection.*

In response to our telephone conversation of last week, I have had the enclosed slides of Georgia Harris's work printed for your use. These slides will provide you with a good overview of Mrs. Harris's career for the period from 1976 to the present.

Mrs. Harris is in full possession of all aspects of the Catawba pottery tradition as it has been passed down from one generation to another from the pre-Columbian Mississippian Period to the 20th Century. She makes both large vessels and miniatures and has been a leading force in a tribal effort to preserve this ancient tradition into the 21st Century. All of the vessels are of museum quality.

The Pipe Tradition

The Catawba potters have always been famed for their production of smoking pipes, and they produce an amazingly large array. She is skilled at making pipes both by hand and through the use of ancient clay squeeze molds.

Revival of Old Shapes and Forms

In 1990 one of the potters found an old Catawba turtle pipe while digging a foundation for a garage at his Reservation home. The discovery of this pipe caused enthusiasm in the community, for this form had not been made by any of the Catawbas for at least a century. The immediate result of this reservation find was a revival of the form. Mrs. Harris was a leader in this movement…

The last Catawba pipe mold maker died in the 1930s and the craft of making pipe molds lay dormant until recently, and the pipe-making tradition was in danger of faltering. Recognizing this danger, Mrs. Harris was instrumental in reintroducing pipe mold making into the community, and today several Catawba potters are actively producing molds for tribal use. This contribution promises to serve the community for years to come.

The Traditional Catawba Peace Pipe

Mrs. Harris also makes some of the finest traditional Catawba peace pipes. Those made by Mrs. Harris are small enough to be smoked. The four stems are low enough on the bowl to draw smoke, and she is able to combine the four stems and three legs into a uniformly graceful pipe. This is done by a complicated pre-Columbian Mississippian construction method which requires all the skill of a master potter.

Larger Vessels

Although Mrs. Harris is in full possession of the entire range of the Catawba tradition and all her vessels are of a museum quality, she is most often sought out for her large vessels. My first purchase from Mrs. Harris was made in 1976:

Georgia Henrietta Harris, 1905-1997

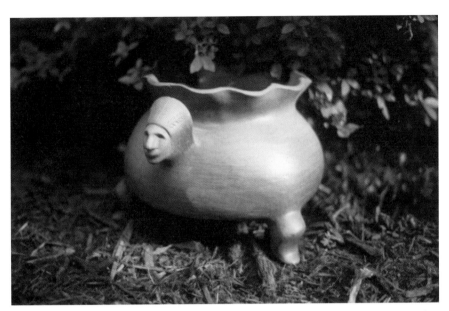

Indian Head bowl with three legs. This was the first vessel that the author collected from this potter. It was also a vessel that helped the potter obtain the award for her work. *Courtesy of the Thomas J. Blumer Collection.*

a large Indian head bowl with three legs. [Since that date, my collection has grown to include over eighty-five vessels made by Mrs. Harris's talented hands.]

Effigies and Effigy Pots

The Catawba potters make a large variety of effigy vessels. However, the only true traditional effigy vessel is the Snake Pot. Few of the potters innovate in their pottery-making efforts but remain firmly entrenched in their tradition and this is as it should be. However, potters of Mrs. Harris's skill are not afraid to venture into uncharted waters and test the tradition. Her Snake Pitcher is a good example of her success in departing from the tradition while still successfully staying within the confines of that tradition. [Both the snake effigy and the Rebecca are traditional but Mrs. Harris dared to combine the two in one vessel.]

A common effigy produced by the Catawba is the owl. In 1979, Mrs. Harris produced [an owl] *and this is part of a slide series made to show Catawba construction methods...The slides are part of the Thomas J. Blumer Catawba Archives at the University of South Carolina Lancaster and may be viewed in Medford Library.*

New Forms

In the 1930s the Catawba learned to make the Southwestern Wedding Vase through a Catawba-taught Cherokee potter who watched Maria Martinez make

this pan-Indian shape at an exposition in Atlanta. Mrs. Harris learned to make this popular form, and collectors of Catawba pottery are eager to obtain examples from her.

Catawba Trade Ware

The Catawba tradition suffered much damage through trade at Cherokee, North Carolina, between 1930 and the early 1960s. The potters were forced to make wares that would prove attractive to tourists. The goal of the dealers was to wholesale at the lowest prices possible. Quality was not of primary concern. Those Catawbas who traded at Cherokee were forced to spend less and less time building and finishing their wares. Mrs. Harris did very little trade at Cherokee simply because she would not compromise the quality of her work. As part of the Catawba tradition which is to sell pottery, she does, however, make the forms that were big sellers at the North Carolina tourist shops. An example of this work is found in…a canoe with Indian heads. Work of this caliber could not be offered to dealers at Cherokee for $.15 per vessel and Catawba of this sort never appeared at Cherokee.

Revival of Catawba Design Motifs

As you will note, many of the [photographs are of vessels decorated] *with incised designs. The Catawba use a restricted number of such designs (straight lines, curved lines, zigzag, crosshatch, swastika, ladder and feather)…In the late 1970s, Mrs. Harris and other senior master potters led an effort to teach these designs to the younger potters. Today Catawba design motifs, untouched by pan-Indian motifs, are enjoying a revival.*

Teaching and Demonstrating Pottery Making

I have already alluded to Mrs. Harris's teaching efforts. From 1976 to the present, she has given one-on-one lessons to a number of Catawba potters. She also taught in the Catawba Class of 1976. She has also welcomed a long line of teachers, journalists and other interested people into her home for demonstrations and sometimes impromptu lessons in Catawba methods. In short, her approach has always been marked by a tremendous generosity. Perhaps her most spectacular demonstrations were given at the Renwick Gallery of the Smithsonian Institution in 1979.

Museum Work

The museums that have worked with Mrs. Harris and boast collections of her work include: The Schiele Museum, Gastonia, North Carolina; McKissick Museum, University of South Carolina, Columbia; The Museum of York County, Rock Hill, South Carolina; and the Columbia Museum of Art, Columbia, South Carolina.

Georgia Henrietta Harris, 1905-1997

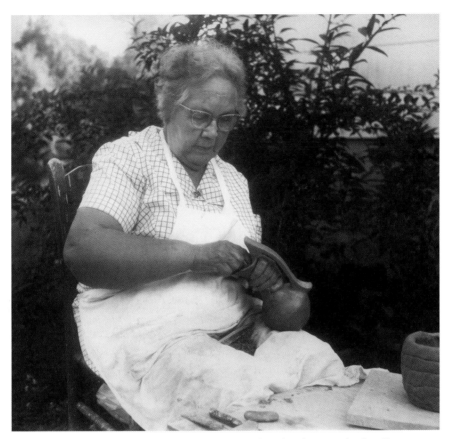

Georgia Harris rubbing a Rebecca pitcher. Courtesy of Steve Richmond, Indian arts and crafts staffer.

Her Legacy

Although I am exceedingly proud to write about Mrs. Harris and her grand accomplishments as a Catawba potter, I feel that her pottery can and does stand on its own. Anyone who examines an example of her work, large or small, can see that the hands of a genius were at work. Her pottery is uniformly excellent and of museum quality...Her work retained this high quality [right up to the end of her life]. *The result is that collectors...clamor for her wares...*

Mrs. Harris's interests, however, [went] *beyond the Catawba pottery-making tradition. During the last fifteen years* [of her life] *she emerged as a resource in Catawba art, history, and culture. The Catawba Memory Book project was initiated largely through her efforts. This on-going project has preserved a tremendous archive of Catawba history and culture...Mrs. Harris was the first to be interviewed and contributed over twenty hours of interviews.* [Today all of this work is stored in the Thomas J. Blumer Catawba Archives and may be studied at the Medford Library of the University of South Carolina, Lancaster.]

Catawba Nation

About a week before the event, the National Endowment for the Arts published a press release on Mrs. Harris. It was taken from available literature supporting Mrs. Harris's nomination:

In the western United States, many Indian pottery traditions thrive and enjoy wide recognition. In the east, however, few Indian pottery traditions survive, and only one—that of the Catawba of South Carolina—maintain a direct connection to the pre-conquest past. "The Catawba potters constitute the only group of Indian potters east of the Mississippi River which has maintained this aboriginal art form in a nearly pure state from pre-Columbian times to the present," according to Catawba history and culture scholar Dr. Thomas J. Blumer. While the Catawba did adapt their pottery products to meet outside demand—about 100 shapes are included in their repertoire—they cling to the coiled clay construction, incised designs, and open bonfire firing methods of their pre-Columbian Mississippian period ancestors. Pottery making has provided important trading goods for the Catawba at least the colonial period, and with the decline of the fur trade in the last 18th century, pottery became the principle source of cash income until the 1930s, when many women turned to work in the textile mills for cash employment. In recent decades, as the last generation of traditional potters has reached its senior years and an interest in Catawba culture has renewed itself, Catawba pottery increasingly has been seen as one of the group's most important links to Catawba tribal identity.

Georgia Harris, born in 1905. During her lifetime, she was the oldest of the active Catawba potters. She was "universally recognized among the potters themselves as the finest potter of this century," according to folklorist Douglas DeNatale. She learned pottery in the traditional informal fashion at the age of nine from her mother, Margaret Harris (1879–1926) and her grandmother, Martha Jane Harris (1834–1936). While from the 1930s to the 1960s, the Catawba pottery tradition suffered greatly through the demand for the most cheaply made Indian goods at such tourist centers as Cherokee, North Carolina, Mrs. Harris refused to compromise the quality of her work, even at the cost of losing a lucrative market. She continued to make museum-quality pieces in the utilitarian large and small vessels and smoking pipes. "When you make anything, make it so it can be used," she affirms. She was largely responsible for the revival of the pipe making tradition through the use of a squeeze mold, a technique borrowed from neighboring Moravian immigrants in the 19th century and modified for Catawba usage. She introduced important shapes to the Catawba repertoire, such as the graceful snake pitcher—derives from the traditional "snake pot" effigy vessel and the long-necked pitcher—and the "wedding vase" introduced from the Southwest. After creating a piece through coil construction and letting it dry, she wet it and rubbed it with

Georgia Henrietta Harris, 1905-1997

smooth rocks to create the velvet-like polished surface typical of Catawba pottery, and then fired it to add the multicolored burnt shades of black and deep orange.

Georgia Harris was known among her Catawba people as a superlative traditional potter and an exceptionally kind, thoughtful, and generous teacher. She remains a role model for other potters. From 1973 to her death, she took on many apprentices and demonstrated in schools and galleries. In 1979, she exhibited and demonstrated at the Renwick Gallery. Her work is sought out by art collectors and is found in many southern museums.

Originally published as parts of the original essay sent to the National Endowment of the Arts to support Mrs. Harris's nomination for this coveted award.

Afterword
Settlement of 1993

I was born on the Catawba Reservation on April 9, 1926. All of my family is Catawba on both sides. My mother was Arzada Brown Sanders, the daughter of John Brown and Rachel George. My father was John Idle Sanders, the son of John Sanders and Martha Harris, the sister of James Harris, the brother of David Adam Harris. My parents had twelve children, six boys and six girls. We always lived on the Indian Reservation, and I attended the Catawba Indian School. I continued my education in the U.S. Army educational system and attended the University of New Mexico after my retirement.

I was drafted into the United States Army on September 9, 1944. My first place of duty was at Fort Jackson, South Carolina, and from there I went to Infantry Basic Training at Camp Wheeler near Macon, Georgia. At the end of my training, I was sent to New York to a port of embarkation and was shipped out for Europe on the Queen Elizabeth with over two thousand other military personnel. We went to Glasgow, Scotland, and from there by train to Southampton, England. From there we took another ship to France.

I was assigned to the 102nd Infantry Division, Company C, 407th Infantry Regiment. I joined my unit in Holland on the Belgian boarder. From there we went on foot to Germany. In April 1945, I caught double pneumonia and was also suffering an ear injury from a five-hundred-pound bomb that was dropped near my unit and damaged my ears. I was shipped to Paris, France, for rehabilitation. On recovery I was shipped back to my unit in Germany.

During the period I was in France, my company had been captured by the Germans just west of Berlin on April 30. The Germans had no prison camp, so they marched our men around in the forest since the Russians had taken the city of Berlin and were fighting westward to join the American forces. The war ended on May 8 and the prisoners were released to the U.S. Army.

Going back to my childhood on the reservation, my family was very involved in politics. I was not eligible to vote since I was a minor, but I went to meetings with my parents. Political meetings were a family event. My dad was a political activist and was elected chief in the 1950s. The tribe always elected spiritual leaders who were members of the Mormon Church.

Afterword

I was released by the U.S. Army on December 18, 1950, and I was elected to the Tribal Council in 1953. In September 1954 my wife, Margaret Alberta Blue, and I moved my family to Salt Lake City, Utah. I spent ten years there and returned home in 1964. At that time, I took part in an adult education program. My job was to encourage younger Catawba to continue their formal education in public schools.

My interest in politics was intensified after I came home from World War II. On August 30, 1975, I was elected as assistant chief in accordance with the tribe's constitution. The tribe was beginning to address issues in the Treaty of 1840 that South Carolina had entered into with the Catawba Nation. Out-of-court political land claim negotiations with the State were not in the best interest of the Catawba Nation. These negotiations, in draft form, contained language that deprived the tribe of its sovereign right to govern itself as a federally recognized Indian tribe. Too much power to govern the nation was given to the State of South Carolina.

I did not want a settlement that excluded the United States from the negotiation participation, for it allowed the United States to avoid acknowledging their obligations to the Catawba as outlined in the Treaties of 1760 and 1763. In fact, I wanted the United States to accept its treaty obligations to the Catawba made legal by the British Crown in the eighteenth century. This was not done. South Carolina's only treaty with the tribe, that of 1840, was not legal because the U.S. Congress did not approve it as obligated by law. The British had recognized the Catawba as a foreign nation with powers to make treaties with foreign governments. Following the independence of the American colonies, the United States adopted this statute as the law of the land.

The settlement negotiations started under Governor Dan McCloud and South Carolina Representative Ken Holland. Non-Indians occupying land in the disputed area got nervous. A state negotiating team was formed. In effect, South Carolina had created a situation that was not tenable. The United States' position was to not enforce the Treaties of 1760 and 1763. The Catawba had leased out all their land under South Carolina's leasing system. But the Treaty of Nations Ford (1840) was illegal in accordance with both British and United States law and violated ancient treaty obligations.

During this period, the Executive Committee of the Catawba Nation granted attorney Judy Leaming-Sanders (Catawba/Cherokee) and I, as assistant chief, the authority to present to the United States Congress a separate bill for re-recognizing the tribes independent of the Settlement Act Bill pending before the U.S. Congress. In 1973 President Nixon had signed a bill rescinding the Indian Termination Act of the 1950s. The Menominee tribe and many other tribes whose federal services had been terminated had been re-recognized by the U.S. Congress. The Native American Rights Fund (NARF) law firm and its attorneys who represented the Catawba in negotiating the land claim settlement act failed to inform the Catawba people that re-recognition could be achieved independent of the Settlement Act.

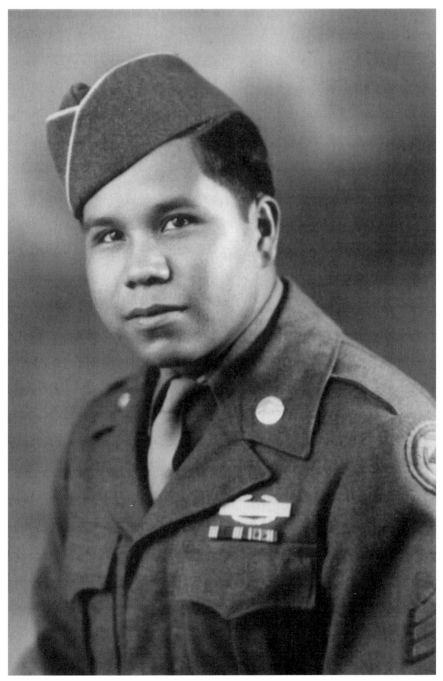

Catawba Councilman E. Fred Sanders in his World War II uniform, probably taken shortly after he was drafted into the U.S. Army and before he was sent overseas. *Courtesy of the Thomas J. Blumer Collection.*

Afterword

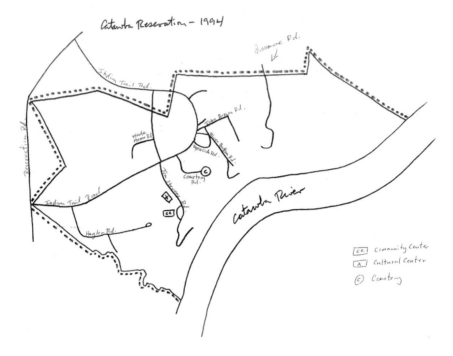

Map of the Old Reservation belonging to the Catawba Nation, taken in 1994 before the road system was improved with grant money. *Illustration by the author.*

They failed to do this as early as 1976 when the Catawba hired NARF to represent the tribe. Miss Leaming-Sanders was not employed by NARF.

The tribe's Termination Act, which took effect in 1962, divided the tribe's Federal Reserve assets among its members and forfeited the tribe's constitution to the U.S. Congress, which pertained only to the federal lands belonging to the tribe. To complicate matters, many Catawba never occupied Federal Reserve land but continued to reside on land held in trust by South Carolina. These people and their lands were not affected by the Termination Act. Federal law said that the Catawba tribe could continue to govern themselves on this South Carolina reserve reservation.

The Catawba had not been terminated as a tribe in 1962. The Catawba people had divided the tribe's federally held assets. The Department of Interior sold some lands, assigned other land to tribal members and divided some money among tribal members. In the process, the Catawba people had forfeited the tribe's constitution, which only controlled federal land. Termination had not dispensed with the tribe's relationship with South Carolina. It only ended the tribe's relationship with the United States for federal services. During federal recognition, the Catawba had two reservations and South Carolina still had obligations. This South Carolina jurisdiction over state reserve lands was never changed until the Settlement Act of 1993.

Settlement of 1993

The Settlement Act of 1993, which was established by the United States Congress, created a quagmire for the Catawba people. Unable to govern themselves under the Constitution that Congress specifically stated would remain in effect to govern the nation until the people adopted a new constitution, the federal laws established by the U.S. Congress in the Settlement Act of 1993 were ignored by the Catawba transitional governing body. In addition, the tribe's attorneys have not protected the laws that govern the Catawba Nation. They have not required the transitional and provisional governing body members to comply with these laws. In fact they have advised them to ignore the tribe's constitution.

As a result, the $50 million paid to the Catawba Nation to settle South Carolina's treaty violations have not been accounted for as expenditures. No financial accounting has been provided to the Catawba people by the secretary of the interior, the State of South Carolina or the tribe's secretary/treasurer, who is responsible for all tribal moneys. Also, in the name of economic development, the tribe established a Bingo enterprise that has netted over $100 million as of today and no financial accounting by the managers of this organization have ever been presented to the Catawba people.

It appears that the secretary of the interior and his agents have allowed the transitional and provisional governing body of the Catawba Nation to violate the Indian Self-Determination Act passed by the United State Congress in 1975 (Public Law 93-638). The Catawba people have not been allowed to participate in their government and manage their internal tribal affairs. It also appears that the secretary's agents allowed the Catawba people's civil rights to be violated as established by federal law by not allowing the people to elect tribal leaders in accordance with the Catawba Constitution. It appears that the tribe has many issues that need to be addressed before the U.S. Congress to clarify the federal statutes established by the U.S. Congress in the Settlement Act of 1993.

<div align="right">

E. Fred Sanders
Former Assistant Chief, Catawba Nation

</div>

Selected Bibliography

This select Catawba Bibliography contains the beginnings of a basic Catawba Nation reference collection. All of these books should be read by anyone beginning to seriously study the Catawba. Most are indexed to allow the user to go directly to the Catawba. As members of the Southern Cult, the Catawba share many cultural similarities with the Cherokee, Chickasaw, Choctaw, Creek, Seminole and other tribes located in Dixie. The Select Catawba Bibliography was published first in *Carologue*, Winter 2000; and in the Catawba People Page. It has been updated for this publication.

Blumer, Thomas John. *Bibliography of the Catawba*. Metuchen, NJ: Scarecrow Press, 1987.

———. *The Catawba Indian Nation of the Carolinas*. Mt. Pleasant, SC: Arcadia Publications, 2004.

———. *Catawba Indian Pottery: The Survival of a Folk Tradition*. Tuscaloosa: University of Alabama Press, 2003.

Brown, Douglas Summers. *The Catawba Indians: People of the River*. Columbia: University of South Carolina Press, 1966.

Coe, Joffre Lanning. *Town Creek Indian Mound: A Native American Legacy*. Chapel Hill: University of North Carolina Press, 1995.

Howard, James H. "The Southeastern Ceremonial Complex and Its Interpretation." *Memoir*, no. 6, Missouri Archaeological Society, 1968.

Hudson, C.M. "The Catawba Nation." University of Georgia Monographs, no. 18, Athens, 1970.

Selected Bibliography

————. *The Juan Pardo Expedition: Explorations of the Carolinas and Tennessee, 1566–1568*. Washington, D.C.: Smithsonian Institute Press, 1990.

Lawson, John. *A New Voyage to Carolina*. N.p.: Readers Microprint Co., 1966.

Lederer, John. *The Discoveries of John Lederer*. N.p.: Readers Microprint Co., 1966.

Lorant, Stefan, ed. *The New World: The First Pictures of America*. N.p.: Duell, Sloan and Pearce, 1946.

McDowell, William L., Jr., ed. *Colonial Records of South Carolina: Documents Relating to Indian Affairs, September 20, 1710–August 29, 1718*. N.p.: South Carolina Department of Archives and History, 1955.

————. *Colonial Records of South Carolina: Documents Relating to Indian Affairs, May 2, 1750–August 7, 1754*. N.p.: South Carolina Department of Archives and History, 1958.

————. *Colonial Records of South Carolina: Documents Relating to Indian Affairs, 1754–1765*. N.p.: South Carolina Department of Archives and History, 1970.

Merrell, J.H. *The Indians' New World: Catawbas and Their Neighbors from European Contact Through the Era of Removal*. Chapel Hill: University of North Carolina Press, 1989.

Milling, Chapman. *Red Carolinian*. Chapel Hill: University of North Carolina Press, 1940.

Reports of Cases Argued...State Reporter 1, May 1828–June 1830.

Rights, Douglas LeTell. *The American Indian in North Carolina*. Winston-Salem, NC: John F. Blair, 1957.

South, Stanley A. *Indians of North Carolina*. N.p.: North Carolina Department of Cultural Resources, Division of Archives and History, 1959.

Speck, F.G. *Catawba Texts*. New York: Reprinted by AMA Press, 1969.

Swanton, John R. *The Indians of the Southeastern United States*. N.p.: GPO, 1946.

Vega, Garcilaso de la, John Greir and Jeannette Varner, trans. *The Florida of the Inca*. Knoxville: University of Tennessee Press, 1951.

Selected Bibliography

Williams, Samuel Cole, ed. *Adair's History of the American Indians*. N.p.: Promontory Press, 1986.

Yorkville Enquirer. "Criminal Business in Court," March 17, 1881.

———. "Homicide Near Rock Hill," March 3, 1881.

Come visit us at
www.historypress.net